IMAGES
of America

AUDUBON

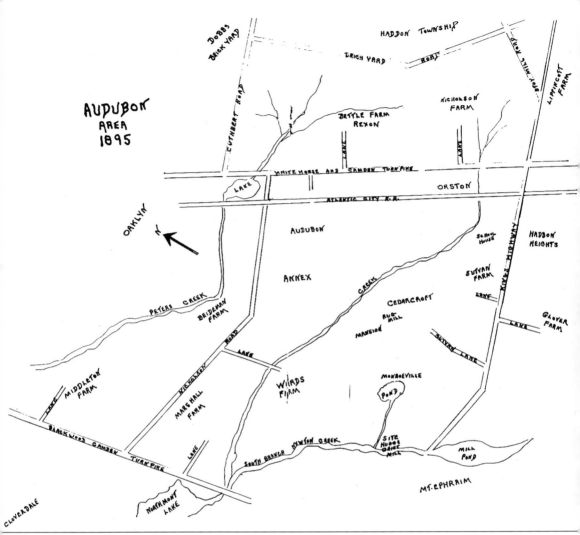

In 1895, the Audubon area had two turnpikes and a railroad.

IMAGES
of America

AUDUBON

Audubon Historical Society

ARCADIA

First published 2004

Published by Arcadia Publishing,
Charleston SC, Chicago IL, Portsmouth NH, San Francisco CA

Printed in Great Britain

Library of Congress Catalog Card Number: 2003115286

For all general information, contact Arcadia Publishing:
Telephone 843-853-2070
Fax 843-853-0044
E-mail sales@arcadiapublishing.com
For customer service and orders:
Toll-free 1-888-313-2665

Visit us on the Internet at www.arcadiapublishing.com

CONTENTS

ACKNOWLEDGMENTS

Thanks go to the gifted and talented students from Mansion Avenue and Haviland Avenue Schools who, in 1995, published a history of the borough of Audubon that will forever be a cherished part of the borough archives. Thanks also go to all those members of the Audubon Historical Society who have donated photographs used in the creation of this pictorial history.

For their efforts in writing, organizing, editing, and proofreading this history, special thanks are extended to Audubon Historical Society members Craig E. Burgess, Walter Casebeer, Ed Helmes, Paul Helmes, Richard Magee, and Jack H. Taylor. Thanks also go to Camden County Historical Society historian Paul W. Schopp and longtime resident Howard Wylde.

The cover photograph, showing Audubon Station, was taken by the late Francis B. Palmer on April 2, 1932. We are especially grateful to Richard W. Clark, Palmer's nephew, for permission to use this fine image on our cover. Despite the Great Depression, Audubon Station was still a very active place in 1932. Note the express wagon in front, the scale by the door, one of the two sets of wooden stairs with no railings, and the upstairs living quarters for the station agent. The railroad closed the station as an operating agency in 1960, although passenger trains continued to stop there until 1965.

INTRODUCTION

A group of London Quakers, including William Penn, drafted the first settlement plans for the area that includes Audubon borough during the 1670s, and the first English settlers arrived in 1682. Named for naturalist John James Audubon, the borough of Audubon obtained its incorporation charter in 1905. The borough seal contains a shield with three plowshares, symbolizing the town's agricultural heritage.

The land was divided into a number of tracts, or farms, by early settlers, including such notables as the Cedarcroft, Bettle, Nicholson, Willits, Sutvan, Ward, and Orston families. Abel Nicholson's great-great-grandparents, Samuel and Ann Nicholson (who purchased the Nicholson house in 1789), arrived in 1775 from Orston County in Nottinghamshire, England.

The Atlantic City Railroad played a major role in Audubon's initial development, and directors of the Camden and Suburban Railway, the trolley operator, promoted Audubon's incorporation as a borough for a stable fare base. In 1892, workmen relocated a carriage house from Chestnut Street over to Cherry Street and converted the building into a one-room schoolhouse. The founding of Audubon's first church, Logan Memorial Presbyterian, occurred in 1893, with an edifice erected on Merchant Street near the White Horse Pike. A group of local residents organized the Defender Fire Company two years later and purchased a horse-drawn chemical wagon for $400. At the beginning of the 20th century, Robert Tweed rented a piece of land from the Cedarcroft tract and acquired a cow on July 3, 1900. Research failed to identify the cow's name, but the purchase inaugurated Suburban Dairies, located on Oakland Avenue across the street from what is now the free public library.

Audubon is home to three Medal of Honor recipients: Samuel M. Sampler, World War I; Nelson V. Brittin, World War II and the Korean War; and Edward C. Benfold, the Korean War. The U.S. Navy has honored Brittin of the U.S. Army and Benfold of the U.S. Navy, both killed in action in Korea, with naval vessels named in their memories: the USNS *Brittin* (christened in 2000) and the USS *Benfold* (christened in 1994).

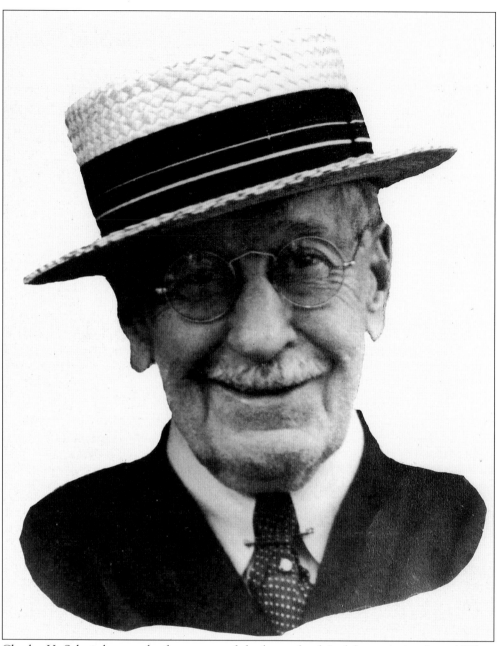

Charles H. Schnitzler was the first mayor of the borough of Audubon, serving from 1905 to 1908. The first home of the Defender Fire Company and Audubon's opera house carry his family name. (Courtesy David Taraschi.)

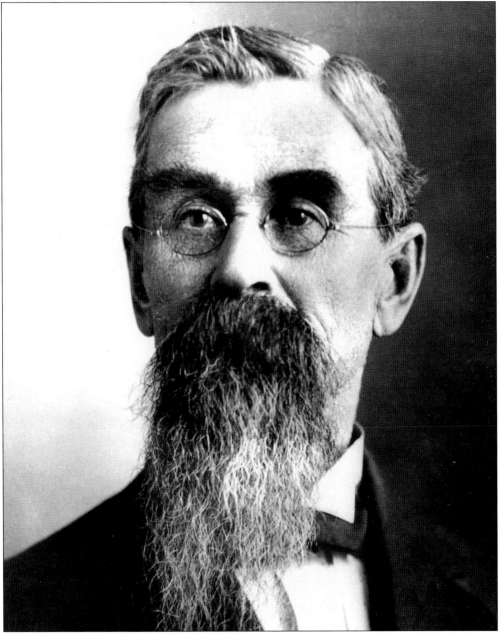

James W. Carman was the second mayor of Audubon, serving from 1908 to 1910. (Courtesy David Taraschi.)

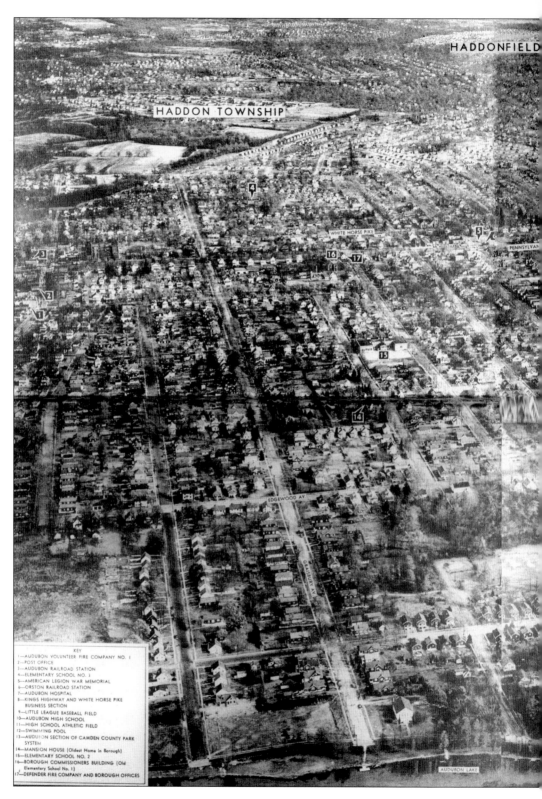

HADDONFIELD

HADDON TOWNSHIP

WHITE HORSE PIKE

PENNSYLVAN

EDGEWOOD AV.

AUDUBON LAKE

KEY
1—AUDUBON VOLUNTEER FIRE COMPANY NO. 1
2—POST OFFICE
3—AUDUBON RAILROAD STATION
4—ELEMENTARY SCHOOL NO. 3
5—AMERICAN LEGION WAR MEMORIAL
6—ORSTON RAILROAD STATION
7—AUDUBON HOSPITAL
8—KINGS HIGHWAY AND WHITE HORSE PIKE
 BUSINESS SECTION
9—LITTLE LEAGUE BASEBALL FIELD
10—AUDUBON HIGH SCHOOL
11—HIGH SCHOOL ATHLETIC FIELD
12—SWIMMING POOL
13—AUDUBON SECTION OF CAMDEN COUNTY PARK
 SYSTEM
14—MANSION HOUSE (Oldest Home in Borough)
15—ELEMENTARY SCHOOL NO. 2
16—BOROUGH COMMISSIONERS BUILDING (Old
 Elementary School No. 1)
17—DEFENDER FIRE COMPANY AND BOROUGH OFFICES

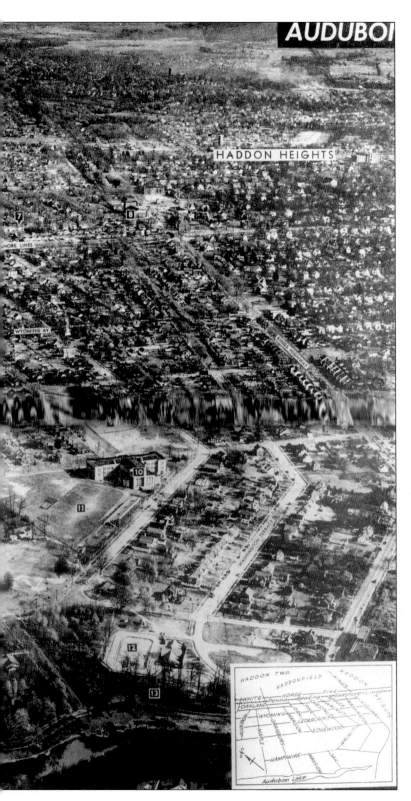

This aerial view shows Audubon. The key lists 17 locations, including the hospital, fire departments, railroad stations, schools, and other public buildings. The map in the lower right corner shows the streets of Audubon.

11

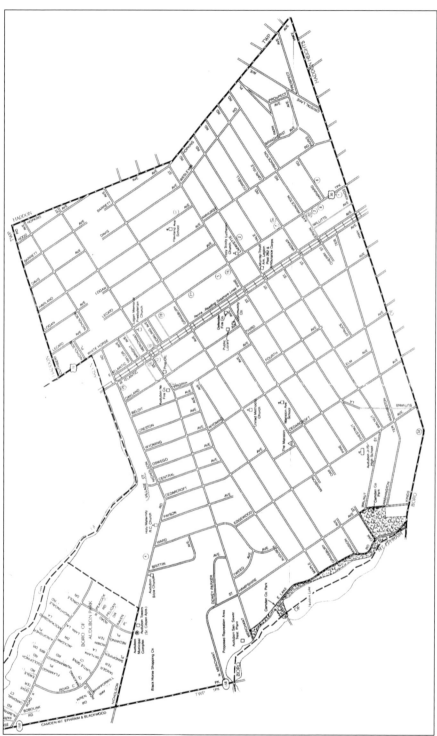

This map of Audubon was printed and published by the Community Map Company of Birdsboro, Pennsylvania. It depicts the location of churches, schools, fire and ambulance departments, parks, and public buildings. (Used with permission of CMC Communications Inc.)

One
EARLY DEVELOPMENT

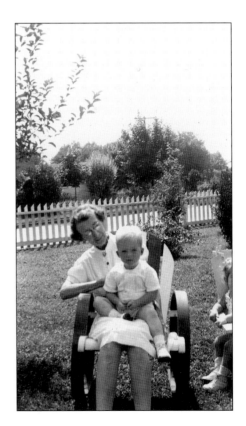

Louise Burgess holds her two-year-old grandson, Craig, in the summer of 1946 at 327 Washington Terrace. Elm Avenue is in the background. The residence is on the property that was once the Willits farm.

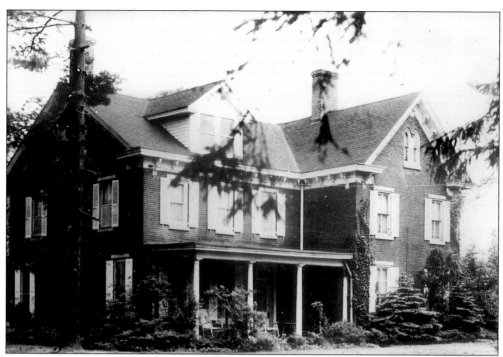

The Mansion House, built in 1857, is the oldest house remaining intact from the time of its erection. It is located on Mansion Avenue and Cedarcroft Avenue, which was later known as the Cedarcroft tract.

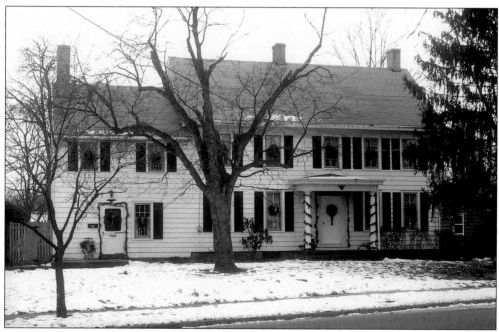

The Ward farmhouse is located on Merchant Street. The bricks used to build it came from England.

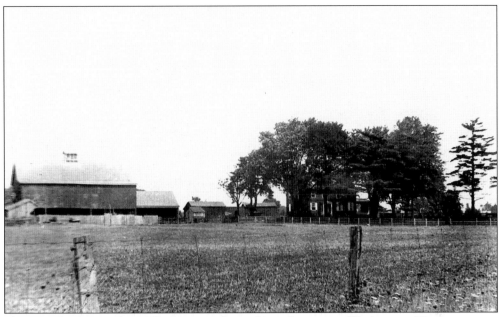

Shown is the Sutvan farm. The barn was located on what is now Washington Terrace.

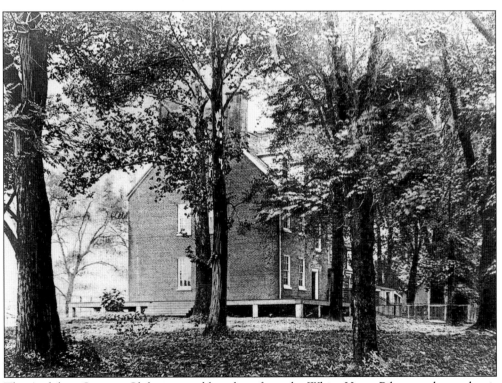

The Audubon Country Club, accessed by a lane from the White Horse Pike, stands on what is now Haviland Avenue.

This 1915 advertisement is for the auction sale of 115 residential lots on the Willets farm. The
property is located on the Kings Highway near the White Horse Pike.

16

FREE $1500.00 FREE
IN VALUABLE GIFTS

COME AND GET SOME OF THESE GOOD THINGS WHETHER YOU BUY A LOT OR NOT

$200.00 - IN GOLD - $200.00
(GOLD PIECES OF U. S. CURRENCY)

Beautiful Upright Mahogany Victrola

$1200.00 WORTH OF MISCELLANEOUS PRESENTS

CONSISTING OF

Elegant Upright Victrolas	Ladies' Gold Watches	Fine Oil Paintings
Rare Vases	Elegant Tea Sets, 6 pieces	Lemaire Field and Marine Glasses
Lemaire Pearl Opera Glasses	Elegant Swinging Ice Pitchers	Silver and Gold Headed Umbrellas
Artistic Bric-a-brac	Fine Imported French Clocks	Novelties in Leather Goods
Beautiful and Valuable Articles in	Mexican Linen Drawn Work	and many other articles too
Silver Deposit on Glass	Gentlemen's Gold Watches	numerous to mention.

Remember there are 500 Presents, all valuable, and GIVEN AWAY FREE, to advertise this great sale. (Presents for everybody)
YOU DO NOT HAVE TO BUY A LOT TO GET THEM—JUST BE THERE—THAT'S ALL

OUR REASON FOR PRESENTING GIFTS AND ENTERTAINMENT

We do this as an advertisement, to have people attend this sale and see for themselves how desirable the property is for a home, investment or speculation. *We positively give away these presents free.* Probably the greater number of them will go to people who do not buy lots at all. The total amount of presents given away will depend on the number of days it takes to sell the lots, as a large number of presents will be given away every day.

NOTE—Some of these Souveniers now on exhibition at TEGG'S DRUG STORE, near Station, Haddon Heights, N. J.

FREE - BOXES OF DELICIOUS CHOCOLATES - FREE
AND GOOD HAVANA CIGARS

Every Lady attending this sale at 2.00 P. M. sharp on Saturday, July 31st, (The opening day of this great sale,) will receive a nice box of chocolates, and every Gentlemen a good 10c. Cigar.

WITHOUT ANY TICKETS OR DRAWINGS

-----REMEMBER THE OPENING DATE-----

SATURDAY, JULY 31st, 1915, at 2 P.M.

And continuing at same hour Monday, Aug. 2d, Tuesday, Aug. 3d, and Wednesday, Aug. 4th, Until Every Lot is sold to the HIGHEST BIDDER, at ANY PRICE

SALE CONDUCTED BY

DYKMAN-NORRIS CO.
Progressive Realty Auctioneers
AND ORIGINATORS OF SCIENTIFIC ORGANIZED LAND AUCTIONS

Main Offices: No. 1011 Chestnut Street, PHILADELPHIA, PA.

SALE ON THE GROUNDS EACH DAY, RAIN OR SHINE

The reverse side of the Willits farm advertisement lists $1,500 worth of "valuable gifts" to be given away during the auction.

17

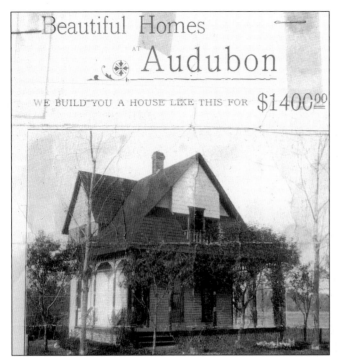

Beautiful Homes
AT Audubon

WE BUILD YOU A HOUSE LIKE THIS FOR $1400.00

In the advertisement to the left, the real-estate office of LeCato Realtors offers to build a beautiful home for $1,400. The office, seen below, was located on Merchant Street at West Atlantic Avenue.

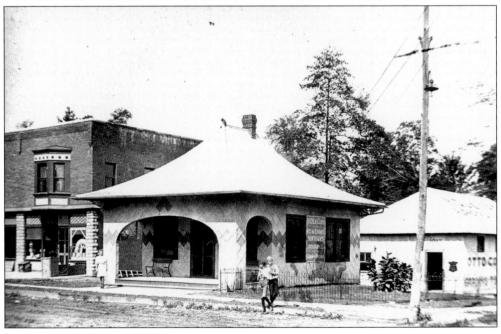

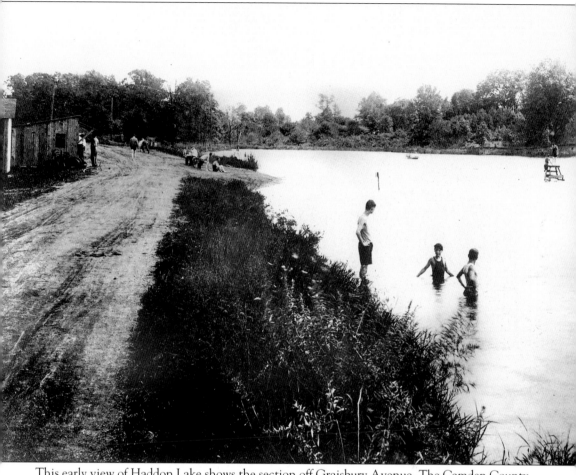

This early view of Haddon Lake shows the section off Graisbury Avenue. The Camden County Park System improved a sand beach at Haddon Lake in 1936.

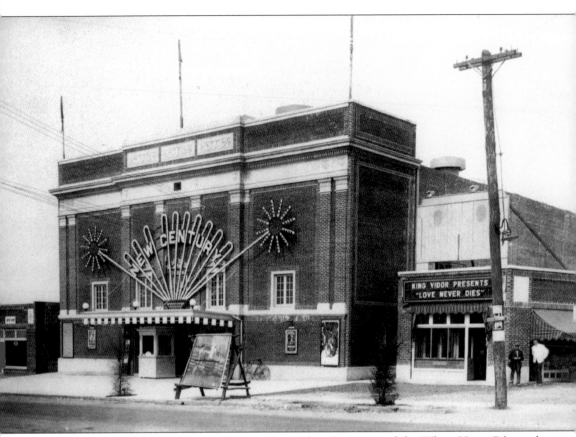

Pictured here is the New Century Theater, located at the corner of the White Horse Pike and the Kings Highway.

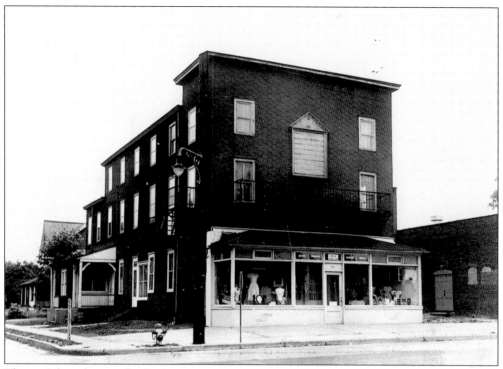

This is Schnitzler's Hall, also known as the Audubon Opera House. It stands at the corner of Pine Street and East Atlantic Avenue.

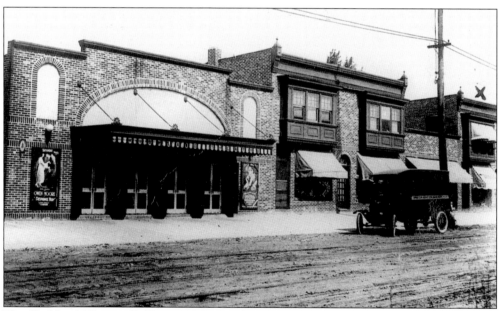

The Highland Theater (left), at 305 East Atlantic Avenue, was part of the business block in what was then known as Haddon Highlands. The Sloans and Skiles delivery truck is parked at the side of the road. Tegeler's drugstore is on the right.

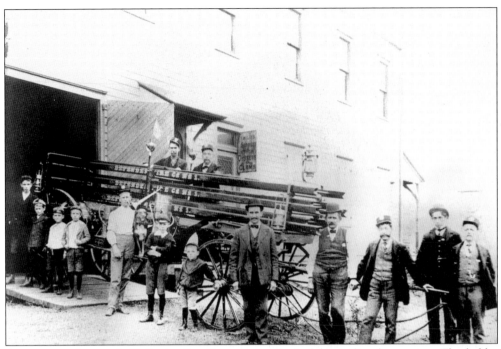

A group stands outside Defender Fire Company with Audubon's first fire engine. The ladder truck was then located in rear of Schnitzler's Hall, exiting onto Pine Street.

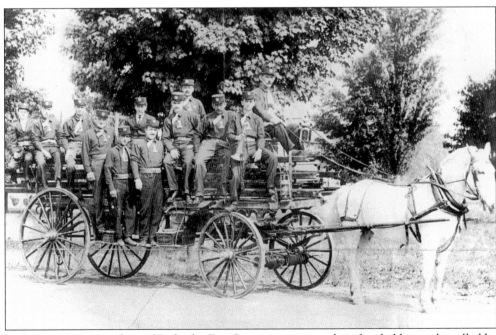

In dress uniform, members of Defender Fire Company pose on their first ladder truck, pulled by a horse from Suburban Dairies. Note the horn that was used to warn traffic.

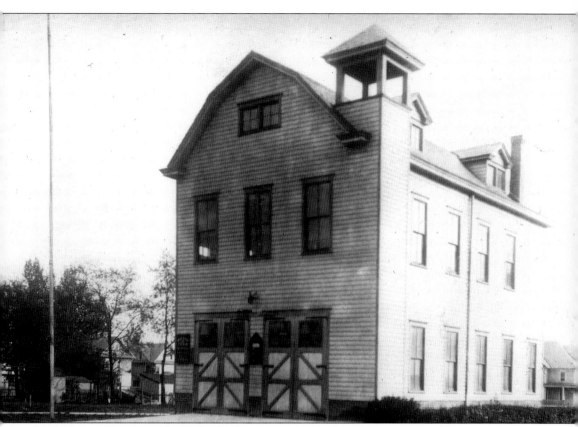

In the horse-drawn era, the Defender Fire Company was located on West Atlantic Avenue at Oak Street.

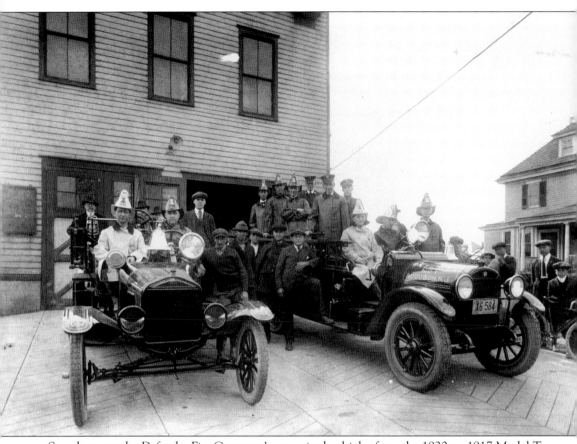

Seen here are the Defender Fire Company's motorized vehicles from the 1920s: a 1917 Model T Ford truck and the first pumper. (Courtesy J. William Birchall.)

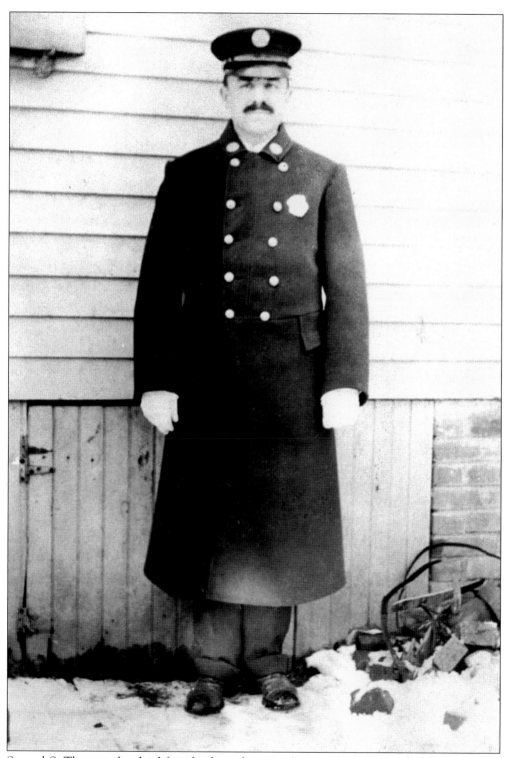

Samuel S. Thomas, the third fire chief, was born on August 19, 1876. He died on March 11, 1938. (Courtesy Harry Thomas.)

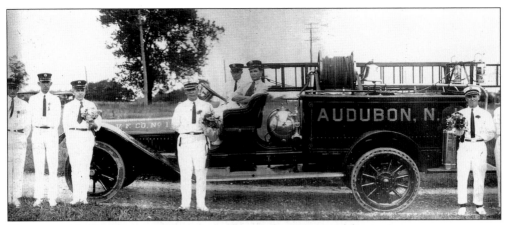

Shown outside Fire Company No. 1 is Audubon's first motorized fire engine.

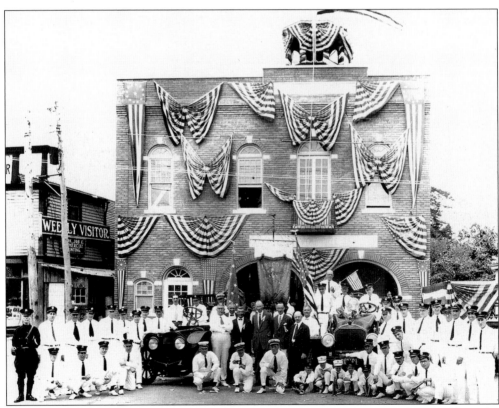

Audubon Fire Company No. 1 is pictured on Merchant Street at Virginia Avenue. Note the uniform of the policeman and the *Weekly Visitor* building (left).

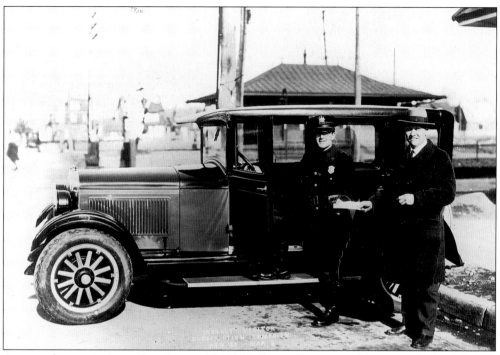

A new police car is pictured on January 22, 1926. Orston Station can be seen in the background.

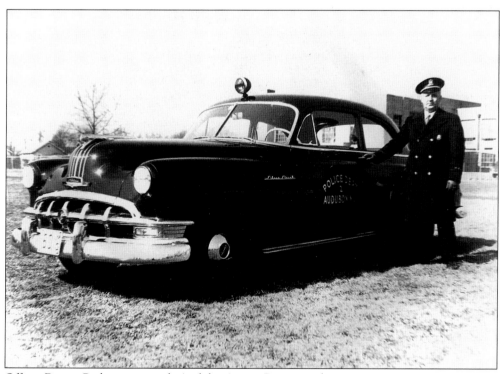

Officer Dewey Parker poses with Audubon's new Pontiac police car.

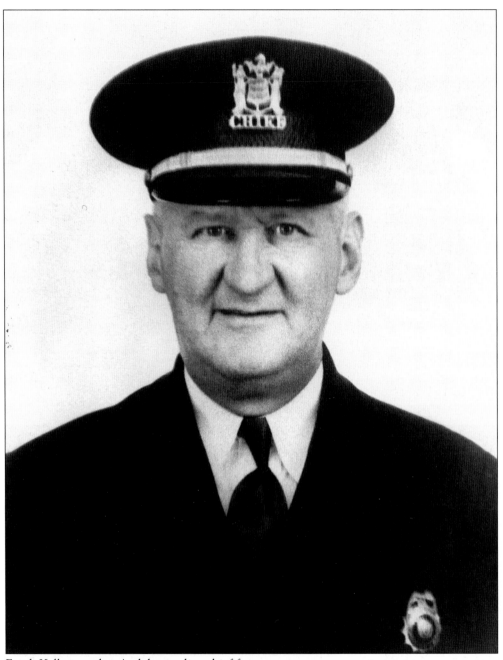

Frank Kelly served as Audubon police chief for many years.

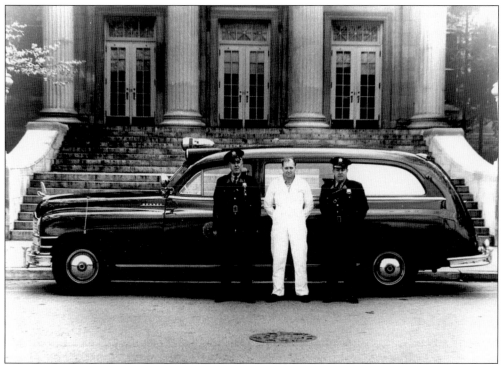

Shown is Audubon's new Packard ambulance. Standing with it are Ray Marriner (left), Frank Hull (center), and Joe Klump.

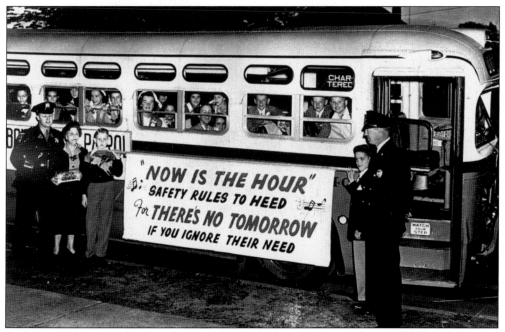

Schoolchildren with the school safety patrol are ready for a trip to Washington, D.C., in the 1950s.

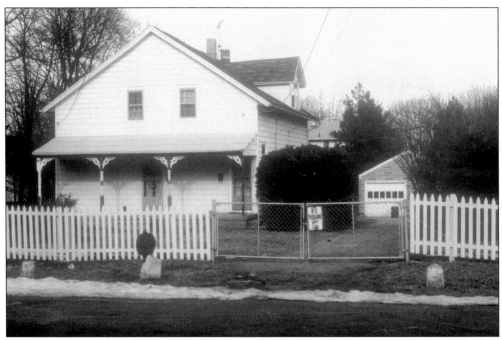

The first Audubon schoolhouse, a building on Cherry Street, is now a private residence.

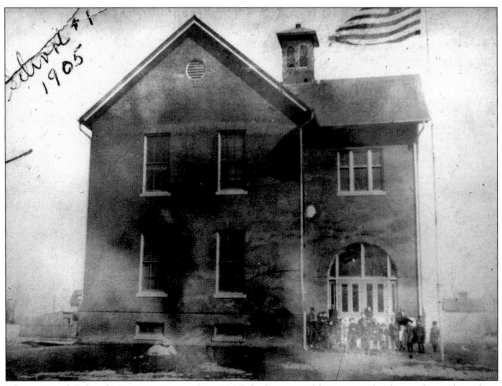

The original School No. 1 is pictured in 1905, before an addition was built on the right side.

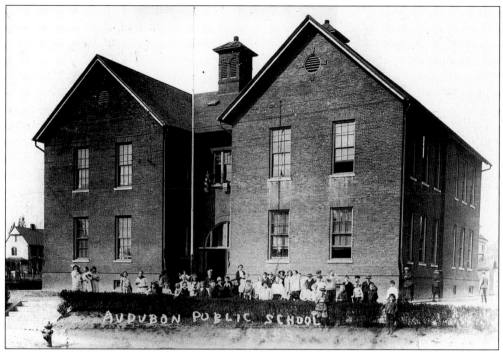

Here is School No. 1 with the addition on the right.

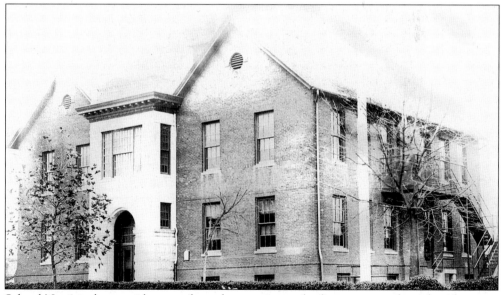

School No. 1 is shown with a new front door section and a fire escape on the right side.

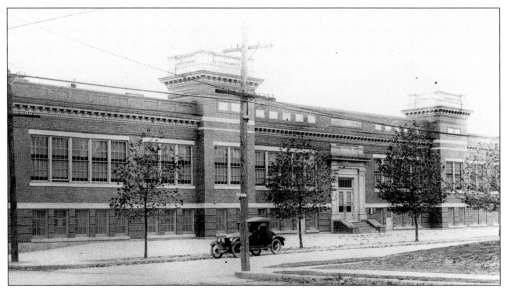

School No. 2, on Wyoming Avenue between Oak Street and Mansion Avenue, is seen as it appeared in the early 1920s. In 1970, the building was torn down and replaced by a new elementary school, now known as the Mansion Avenue School. It serves students on the west side of the White Horse Pike.

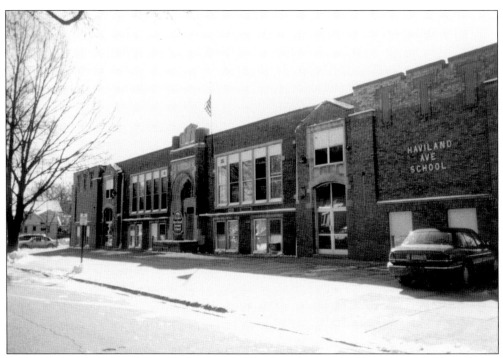

School No. 3 stood on Haviland Avenue between Graisbury Avenue and Pine Street. Renovations to the building were made in 1979, and the name was changed to Haviland Avenue School. It serves students who live on the east side of the White Horse Pike.

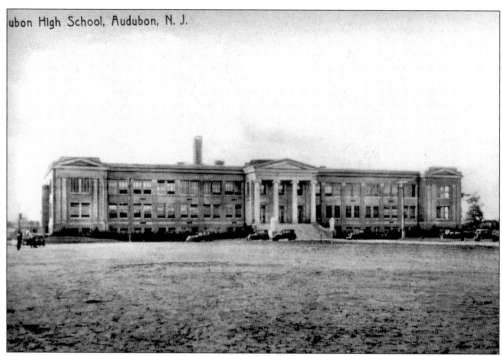

Shown is Audubon High School in the 1930s. This picture was taken when the chimney was still intact, before it was struck by lightning in 1975.

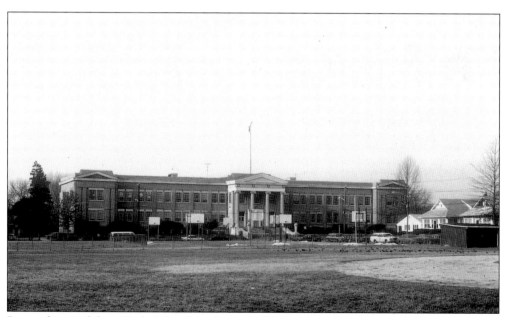

Pictured is Audubon High School in the early 1980s. Note the shortened chimney and the basketball courts in the foreground across Edgewood Avenue.

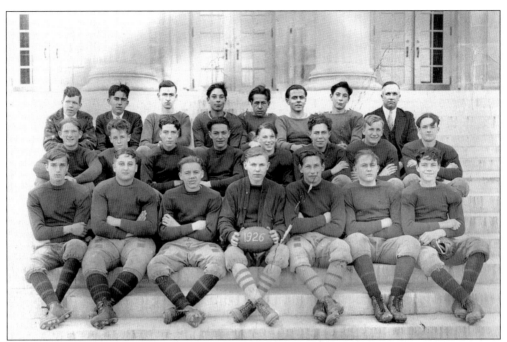

The 1926 Audubon High School freshman football team was coached by Elton E. Ellis (back row, far right).

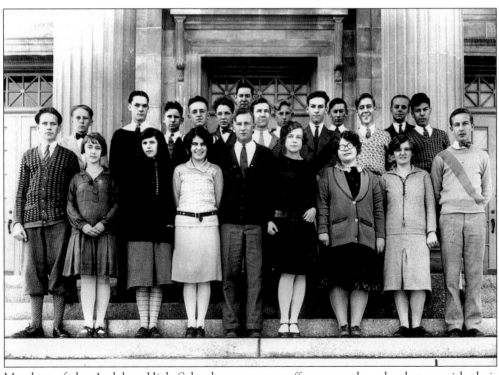

Members of the Audubon High School newspaper staff pose on the school steps with their adviser, J. Paul Dare (back row, center).

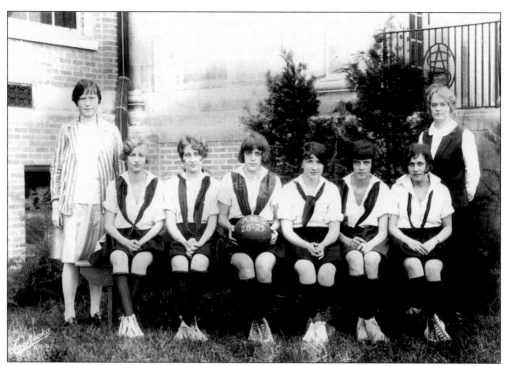

The 1928–1929 Audubon High School girls' basketball team was coached by Alice Baulig.

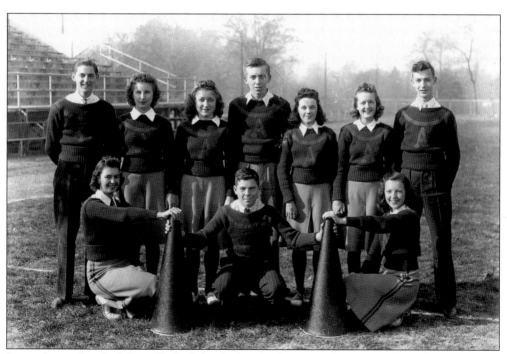

In uniform, the Audubon High School cheerleading squad poses out on the field. John Matousch stands in the back center.

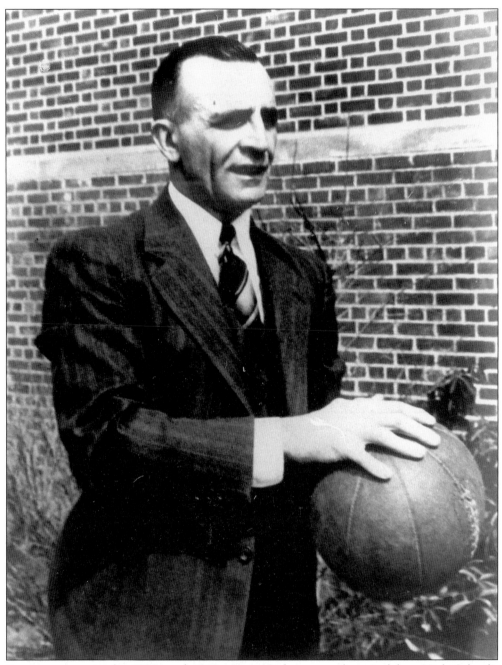

For many years in the 1930s and 1940s, James Pickens served as Audubon High School's athletic director and coach.

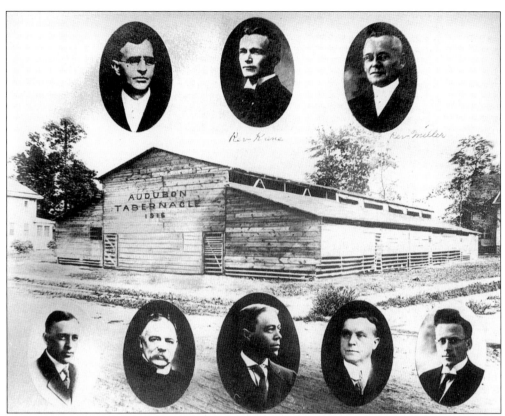

The Audubon Tabernacle, located at Merchant Street and Virginia Avenue, is pictured in 1916.

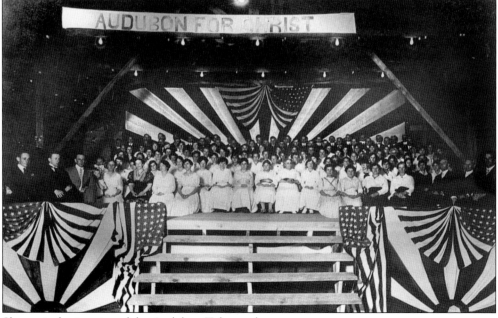

Shown is the interior of the Audubon Tabernacle.

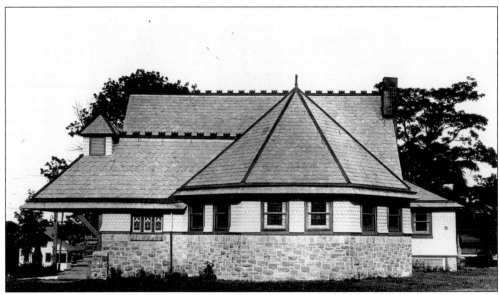

This is the original building of Logan Memorial Presbyterian Church. Built in 1893, it is located at the White Horse Pike and Merchant Street.

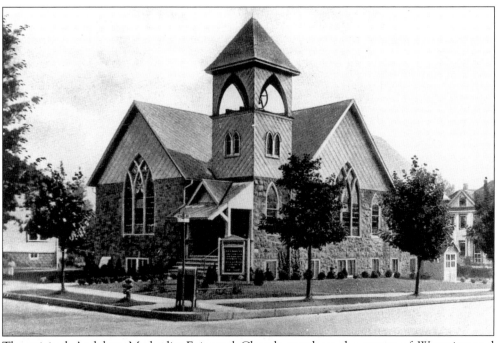

The original Audubon Methodist-Episcopal Church stood on the corner of Wyoming and Graisbury Avenues.

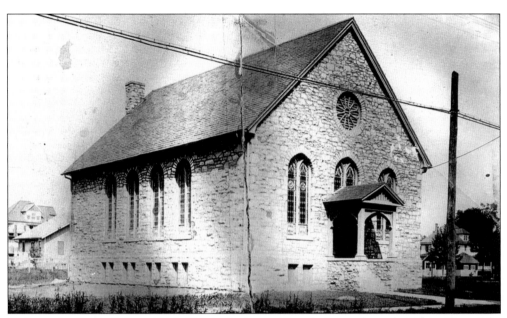

This was the first building of Holy Trinity Lutheran Church. It stands on the White Horse Pike at Lafayette Road.

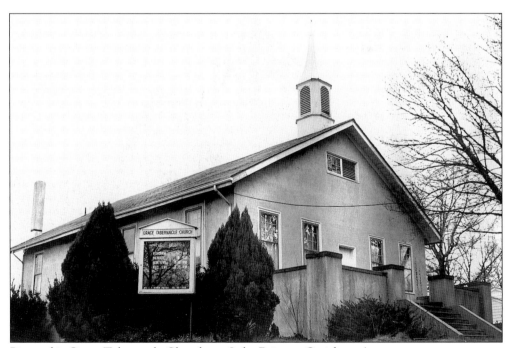

Pictured is Grace Tabernacle Church, on Lake Drive at Graisbury Avenue.

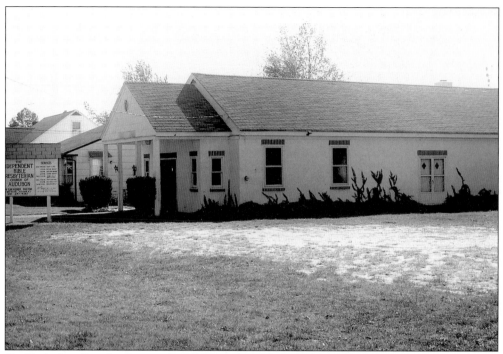

On Nicholson Road at Brittin Avenue is Independent Bible Presbyterian Church.

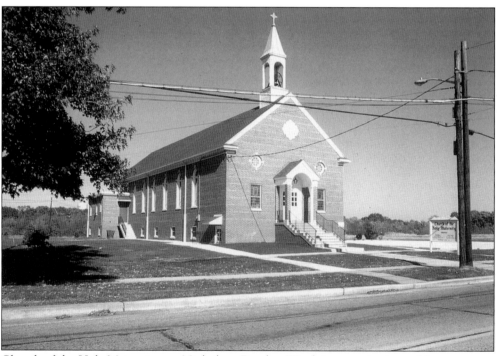

Church of the Holy Maternity, on Nicholson Road at Ward Avenue, is pictured here.

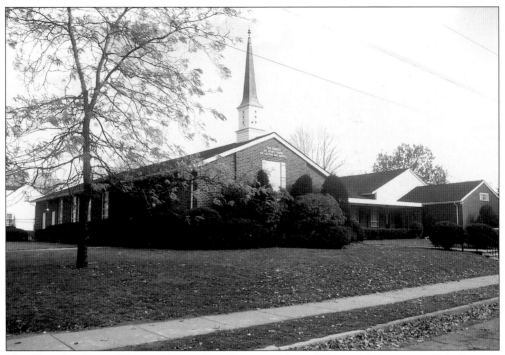

The Church of Jesus Christ of Latter-Day Saints stands on Edgewood Avenue at Oak Street.

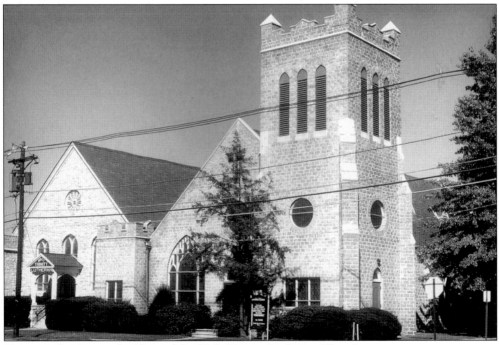

Shown is the present building of the Holy Trinity Lutheran Church.

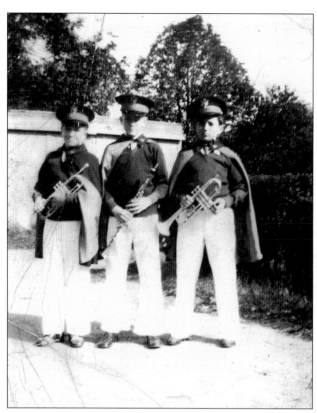

In uniform, three members of the Audubon High School band pose with their instruments in 1932. They are Harry Thomas (left), George Young (center), and Joe Cohen.

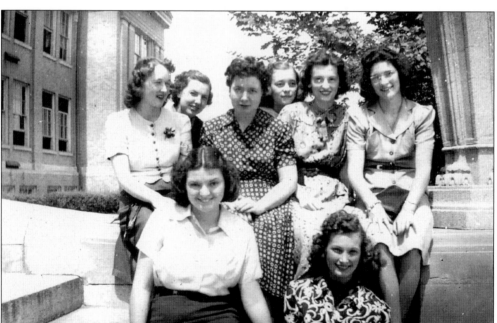

Audubon High School students gather outside the school. From left to right are the following: (front row) Evelyn May and Tessie Chando; (middle row) Rose Downer, Claire White, Rita Gendek, and Ellen White; (back row) Dot Le Gates and Edith Fulleman.

Two

HISTORICAL
HIGHLIGHTS

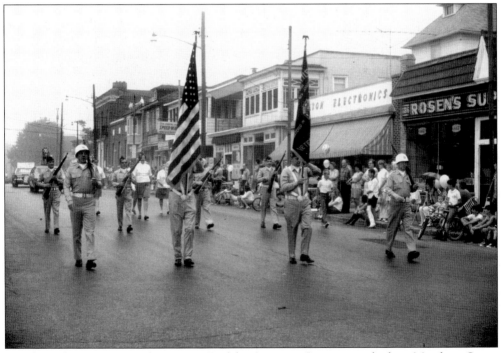

Members of Murray-Troutt Post No. 262 of the American Legion march along Merchant Street in the early 1970s.

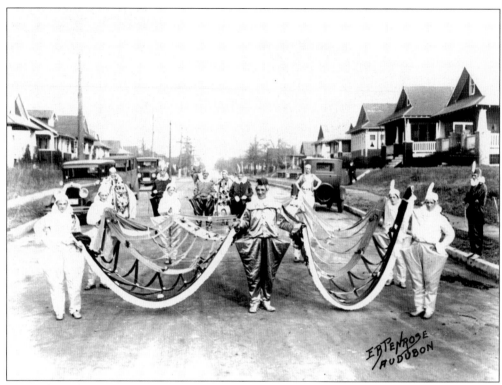

Pictured are elegantly costumed members of the Audubon New Year's Association. The man in the front center is Andy Glaze.

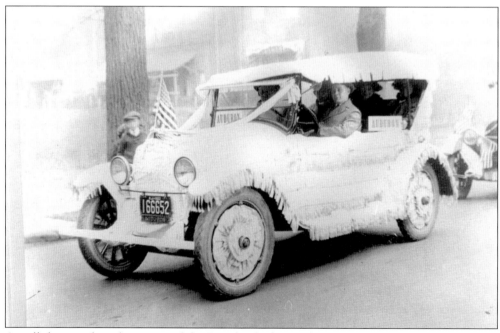

A well-decorated car forms part of the Fourth of July parade in 1922.

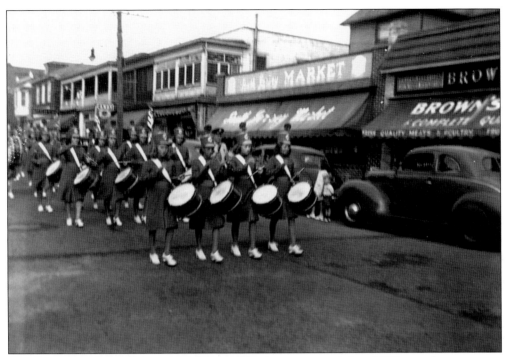

The Bon-Bons, the Audubon girls' drum and bugle corps, march in a 1940s parade.

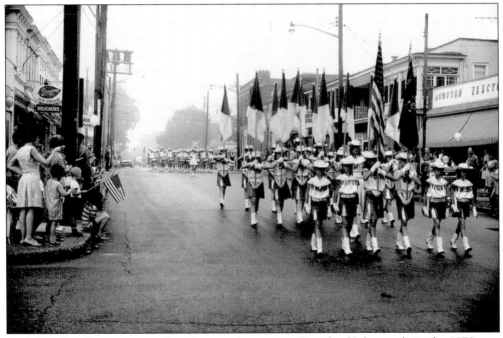

Audubon Bon-Bons, in cowgirl uniforms, take part in a Fourth of July parade in the 1970s.

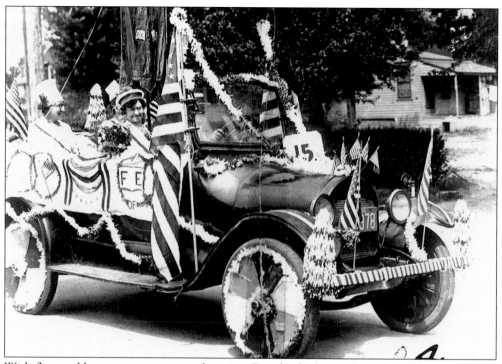

With flags and banners, a car moves along in a Fourth of July parade in the mid-1920s.

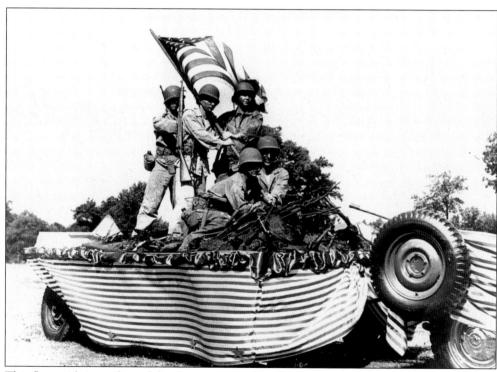

This float with its replica of the flag raising on Iwo Jima was part of the Fourth of July parade of 1947.

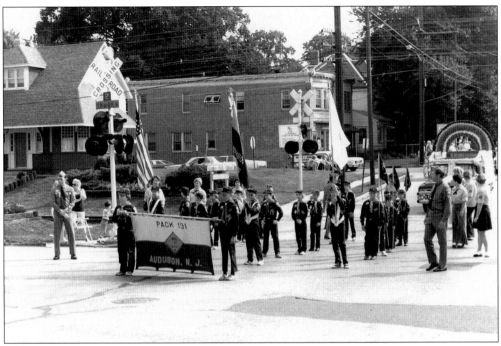

Audubon's Cub Scouts pause just beyond the railroad crossing in a Fourth of July parade in the 1970s.

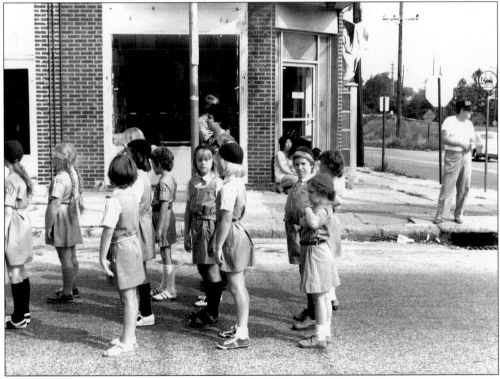

Members of Audubon's Brownie troop line up for a Fourth of July parade in the 1970s.

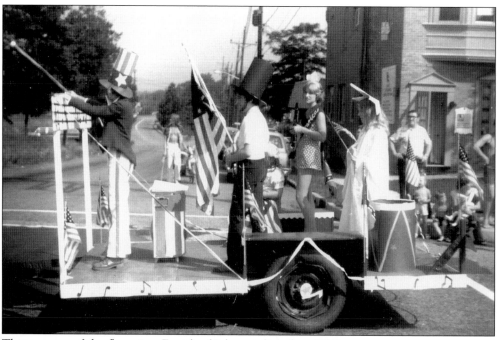

This was one of the floats in a Fourth of July parade in late 1960s.

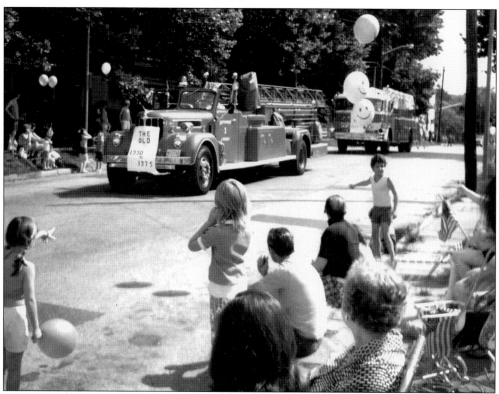

Fire engines are an important part of a parade. These two are applauded by the crowd watching a Fourth of July parade in 1975.

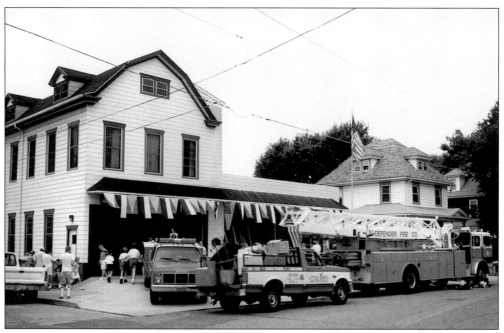

The Defender Fire Company is pictured during Fourth of July celebrations.

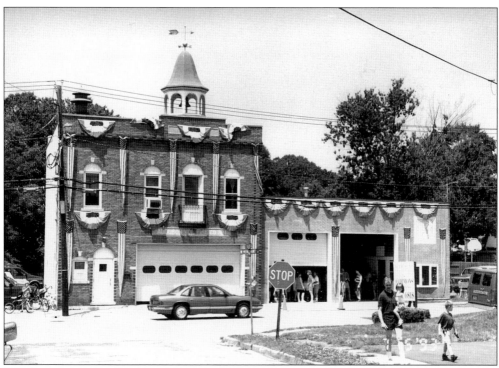

Fire Company No. 1 holds an open house on the Fourth of July.

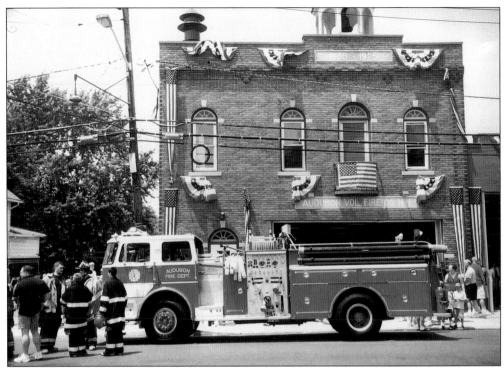

Shown is Fire Company No. 1, located on Merchant Street at Virginia Avenue.

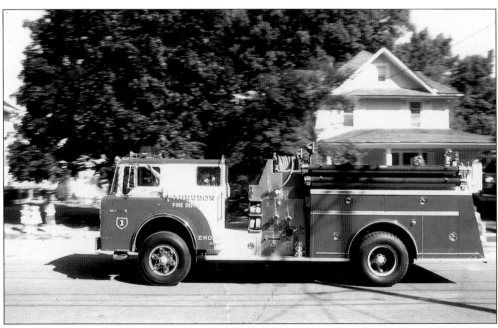

Fire Company No. 1 takes part in a Fourth of July parade.

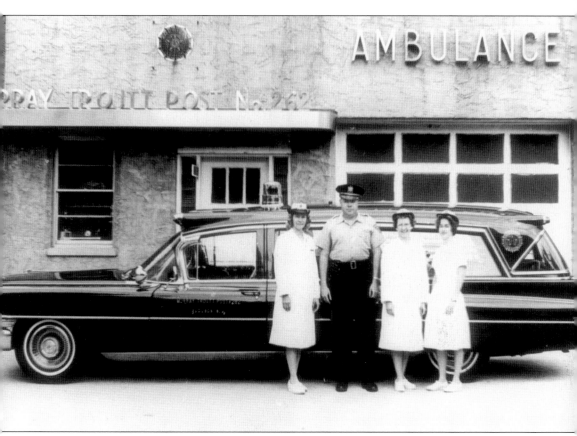

Seen are the American Legion post ambulance and staff in the 1950s.

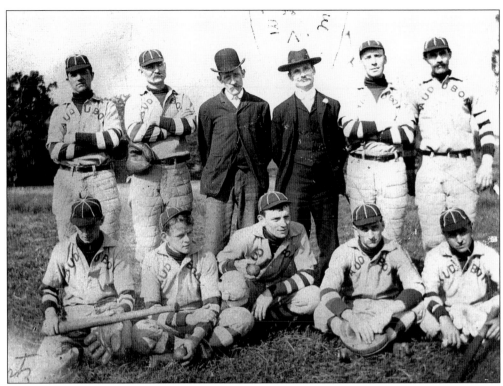

Posing for a photograph are members of Audubon's notorious baseball team of the 1920s.

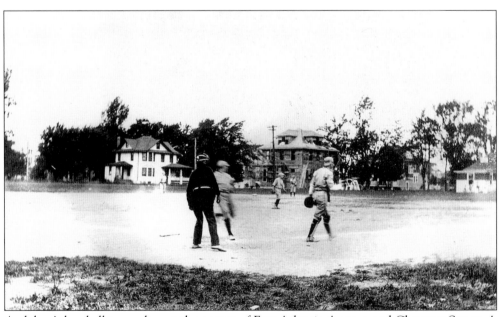

Audubon's baseball team plays at the corner of East Atlantic Avenue and Chestnut Street. A Wawa now stands where the center house is located, on the White Horse Pike.

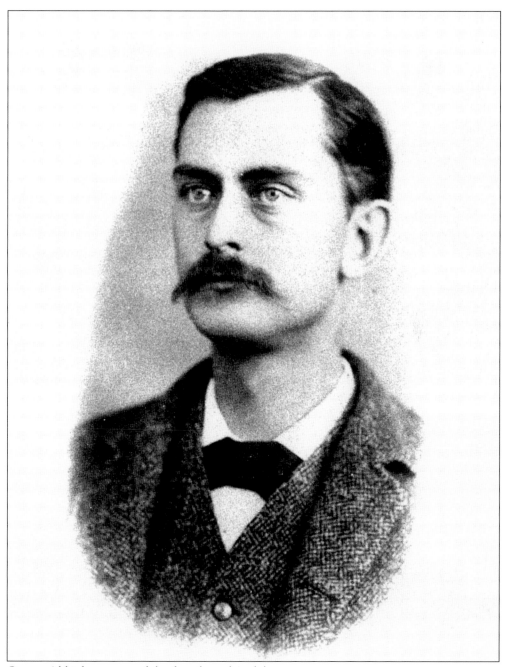
George Aldrich was one of the founders of Audubon.

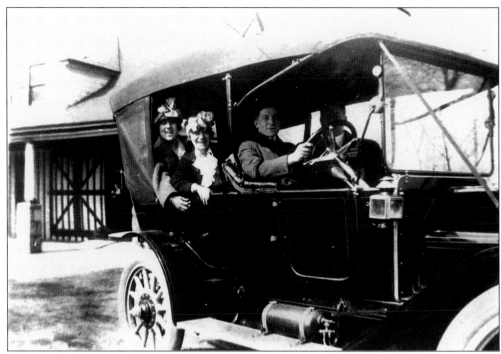

Harry LeCato, pictured in his car in 1912, was the developer of East Audubon.

Harry Thomas sits on a Model T Ford *c.* 1916.

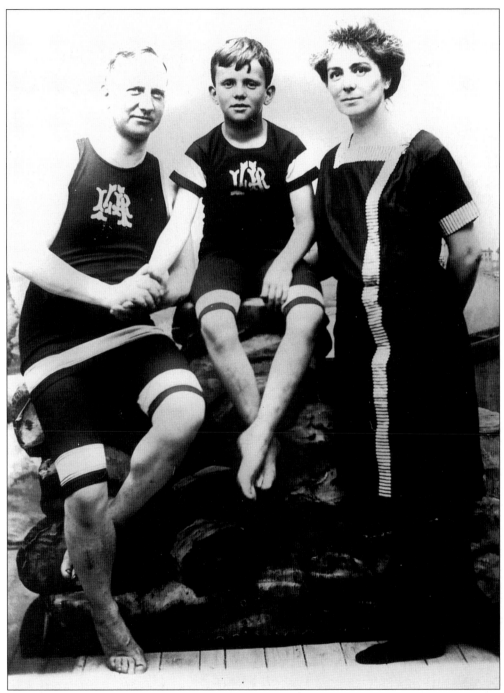

Dr. I. Grafton Sieber poses with his son and his wife. Sieber was one of Audubon's early family physicians. He practiced medicine from his home, located on the corner of Merchant Street and Oakland Avenue.

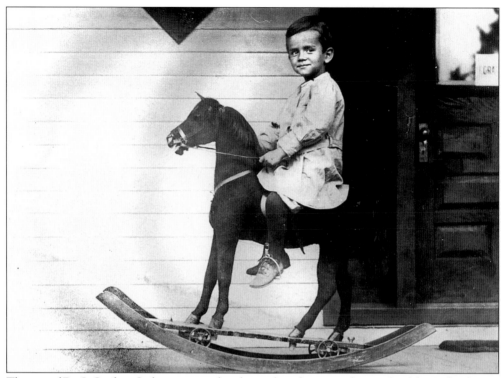

The son of Dr. I. Grafton Sieber enjoys riding his rocking horse on the porch of the Sieber home.

This home is decorated for a Fourth of July in the 1920s.

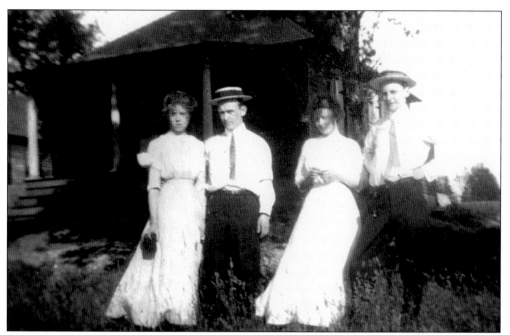

Dressed in the latest fashion, these four young people pause outside 420 Oak Street.

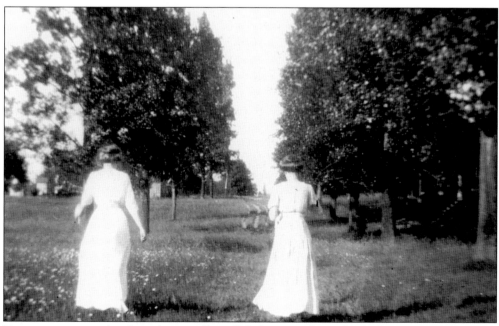

Two young women head out for a stroll on Oak Street in the early 1900s.

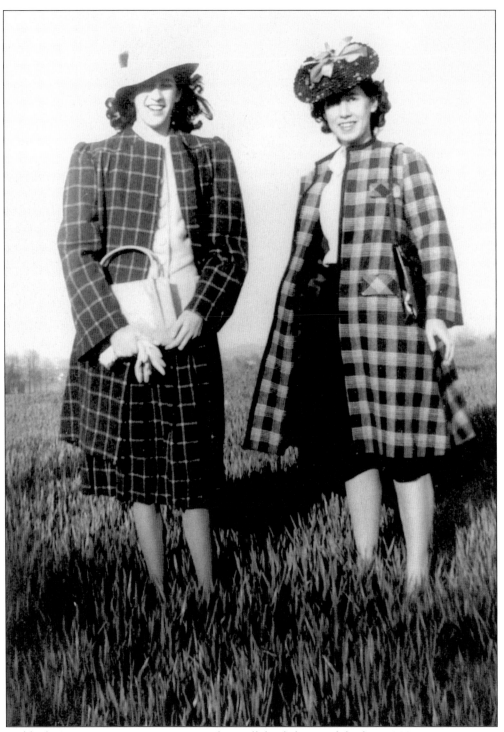

Ankle deep in grass, two young women show off the fashions of the late 1930s.

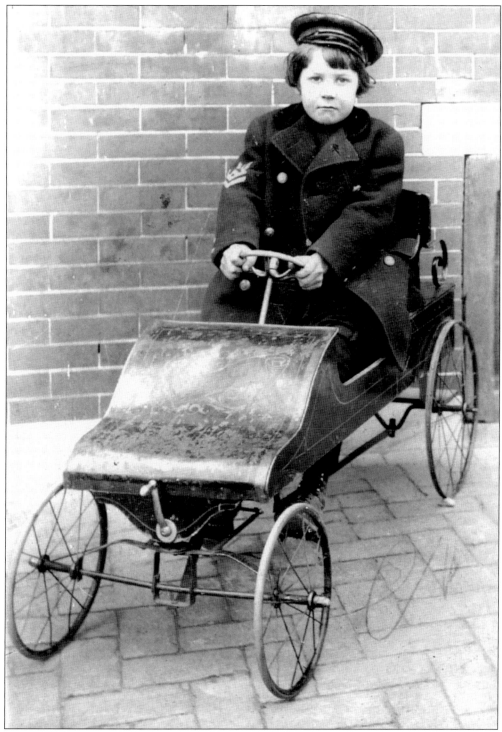

A youngster poses in an early four-wheeler, equipped with a hand crank, foot pedals, and a steering wheel.

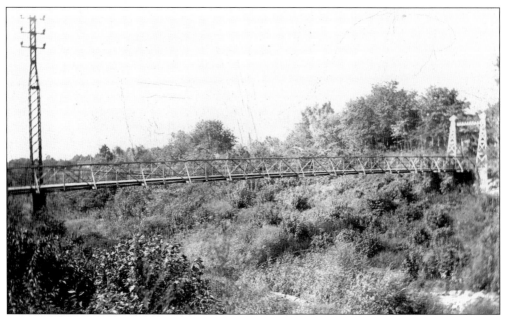

The swinging bridge was constructed over the gully on Haviland Avenue at Merchant Street. The bridge was torn down in 1942 to provide scrap metal for the war effort. (Courtesy Grace Costello.)

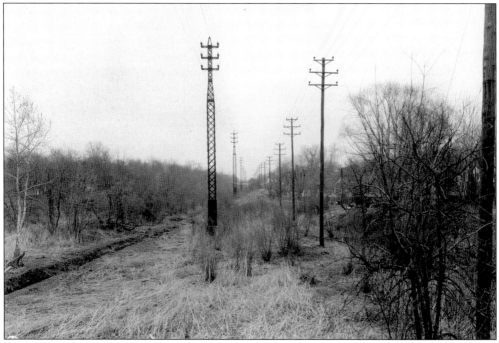

Seen is the gully in Audubon in 1957. A planned rail line from Brooklawn to Haddonfield was designed but never completed. In the background is the old Nicholson Road pedestrian bridge. (Courtesy Stanley S. Mojta.)

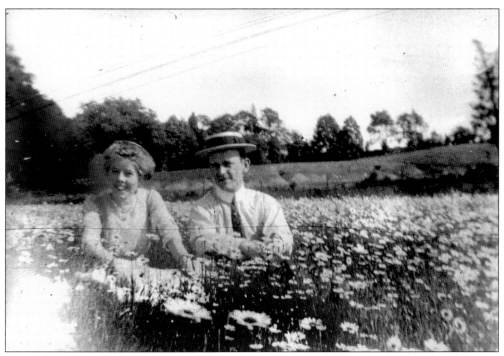

A couple sits in a field of daisies on Oak Street in 1912.

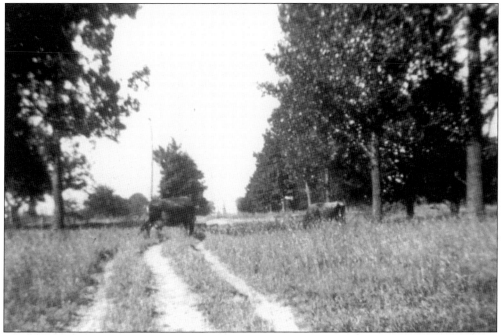

This picture shows the Keller cows on Oak Street close to Cedarcroft in 1911. The Keller farm was the first of the Suburban Dairies on Oakland Avenue. At the dairy in Audubon, owners Robert Tweed and William Matlack processed milk that was then delivered to residents. On February 1, 1939, Suburban merged with Abbotts Dairies, a company that distributed milk throughout Philadelphia, Camden, South Jersey, and the seashore.

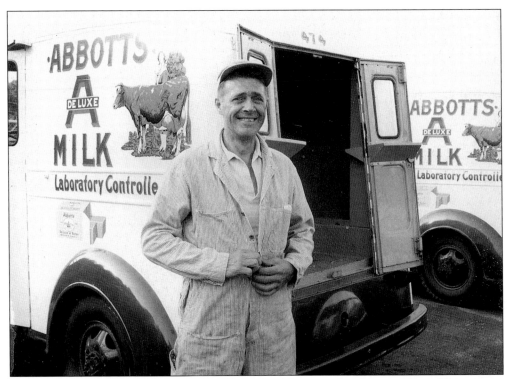

One of the drivers for Abbotts Dairies prepares for deliveries of milk to residents. This picture was taken in the early 1940s after the merger of Audubon's Suburban Dairies with the larger company.

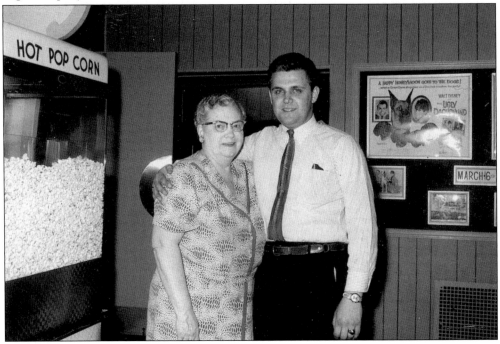

Pictured inside the Century Theater are Agnes Stanton and the assistant manager.

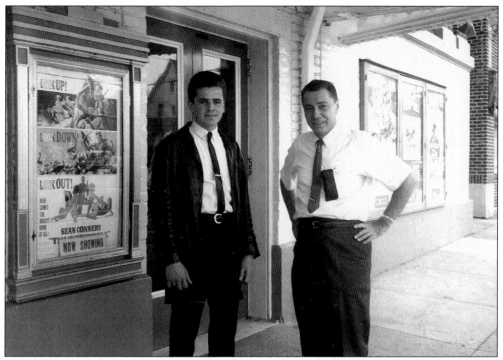

Harry Sullivan (right) was the manager of the Century Theater. He stands with an usher outside the theater.

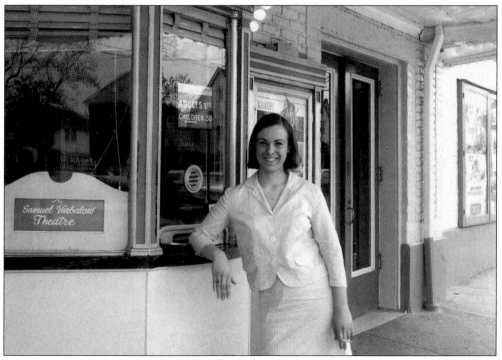

A cashier poses by the ticket window of the Century Theater in 1966. In those days, the prices of tickets were $1.25 for adults and 50¢ for children.

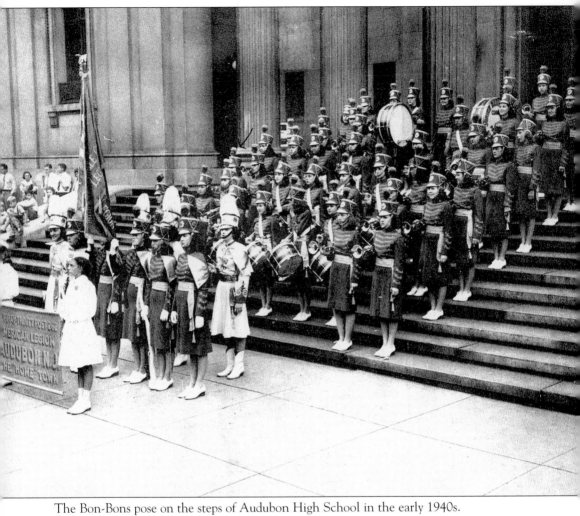

The Bon-Bons pose on the steps of Audubon High School in the early 1940s.

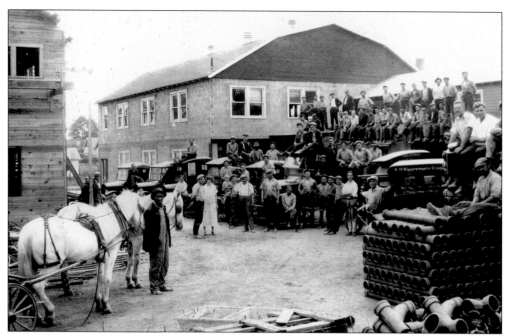

Knoettner's Plumbing is shown under construction in the early 1920s.

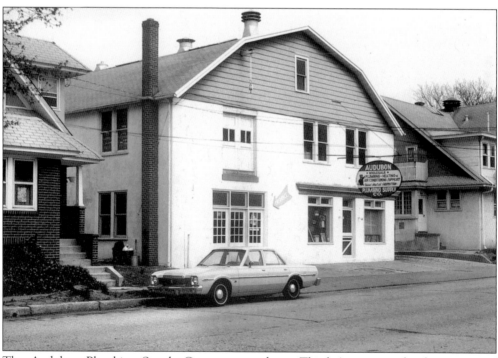

The Audubon Plumbing Supply Company stands on Third Avenue at the former site of Knoettner's Plumbing.

Pictured is the intersection of the White Horse Pike and Pine Street in the mid-1930s. Policemen and local business leaders discuss the new traffic signal that is now in place at the corner.

Shown is the first home of the Murray-Troutt American Legion Post No. 262 on the corner of Graisbury Avenue and Lake Drive. It is now the Grace Tabernacle Church.

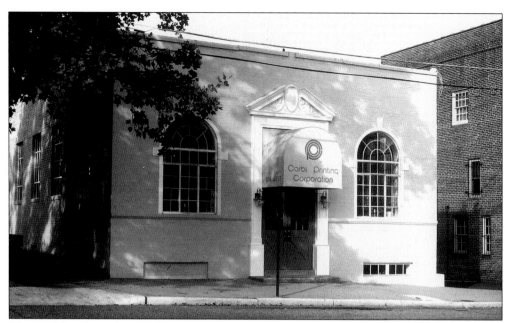

The Audubon branch post office was located in this building on West Atlantic Avenue. Today, the building is the home of Corbi Printing Corporation. The post office moved to the corner of Merchant Street and Oakland Avenue, where it remained until 2000. (See photograph below.) It then relocated to the Black Horse Pike Shopping Center, where it remains today.

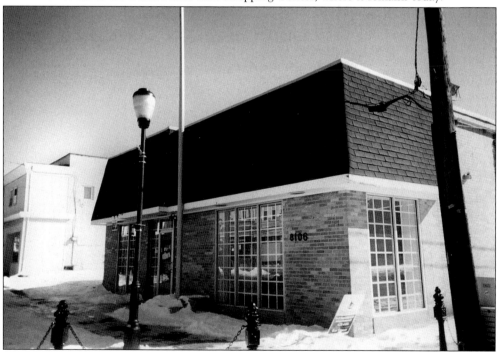

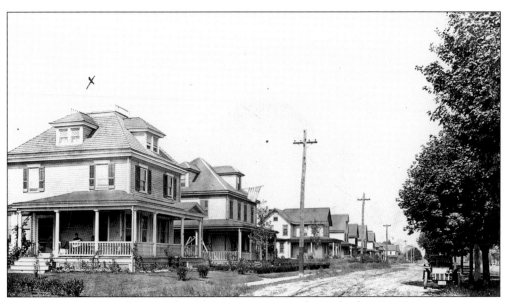

Houses line one side of West Atlantic Avenue just past the Defender Fire Company.

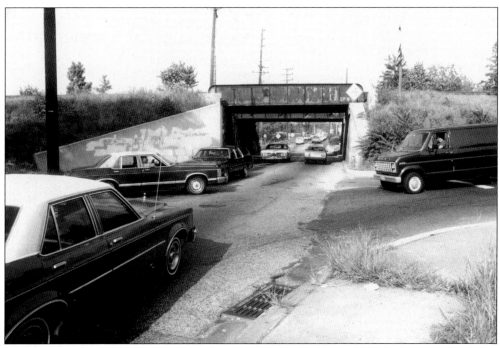

Rare traffic congestion is seen at the railroad and trolley bridge over Nicholson Road at West Atlantic Avenue.

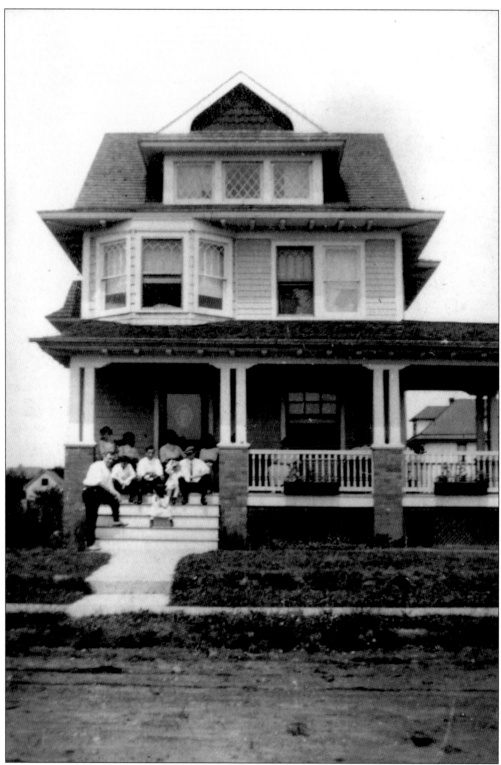

The family gathers on the front porch of this Audubon home in the 1920s.

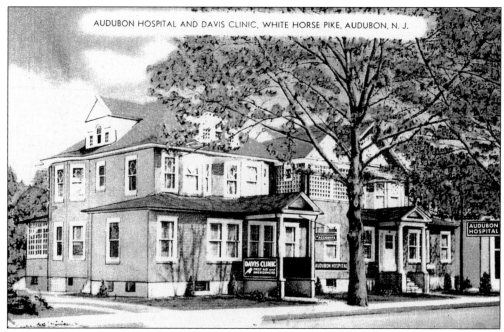

Audubon Hospital was founded by Dr. Ralph W. Davis Jr. for the diagnosis and treatment of surgical cases. The hospital was located on the White Horse Pike between Chestnut Street and the Kings Highway.

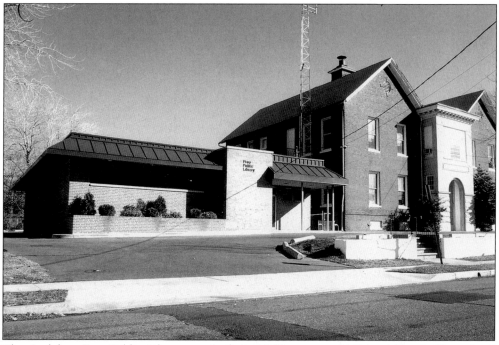

The Audubon Free Public Library was built in 1957 next to old School No. 1. The school building (right) is now home to a preschool and serves as the community center, where local organizations hold regular meetings.

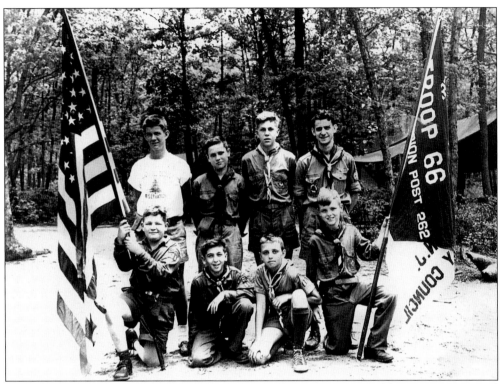

Members of Audubon Boy Scout Troop No. 66 pose for a group picture. The troop is sponsored by American Legion Post No. 262.

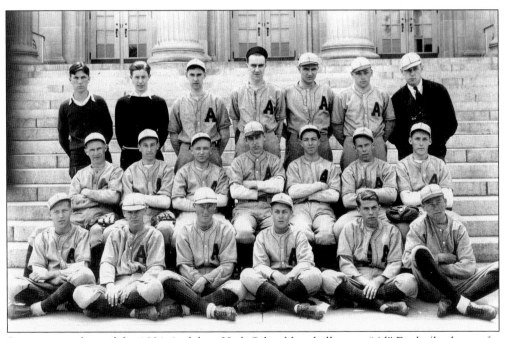

Seen are members of the 1931 Audubon High School baseball team. "Al" Engle (back row, far right) was the manager, and Paul Middleton (middle row, center) was the team captain.

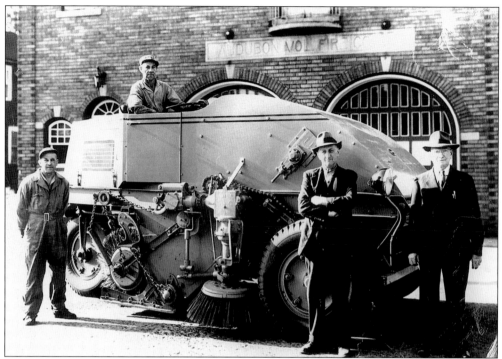

This large machine is Audubon's new street sweeper. Showing it off are four men, including Comr. James Caskey (right). Notice the unique doors on the front of Fire Company No. 1.

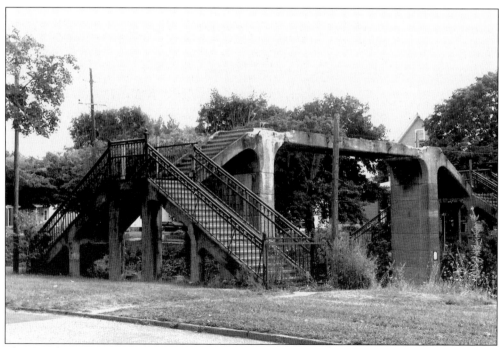

The Graisbury Avenue pedestrian bridge over the railroad is pictured just before its demolition in the mid-1980s.

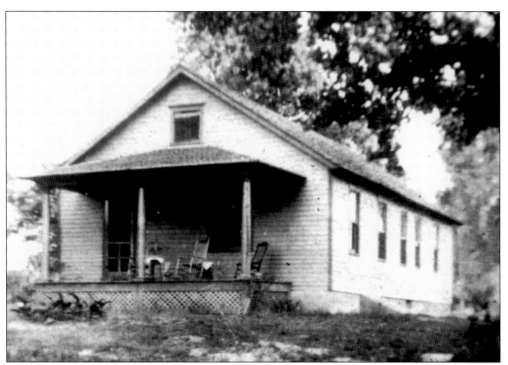

Pictured is a house on Oak Street in 1912.

The same Oak Street house is shown in 1988.

Dr. Herbert Owen's house was located on the northwest corner of the White Horse Pike and Merchant Street. The animal hospital can be seen in the background.

This house, located at the corner of Pine Street and West Atlantic Avenue, was the home of Dr. Henry Tatum.

Members of the Low family survey storm damage on Virginia Avenue c. 1957.

This damage on Pine Street was inflicted by Hurricane Hazel in 1955.

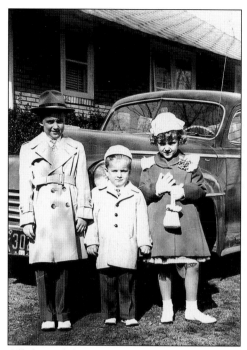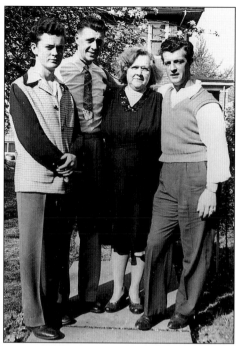

All dressed for Easter in 1955 are these three young members (left) of an Audubon family. A family group (right) poses in a backyard on Pine Street on a Sunday afternoon in the 1940s.

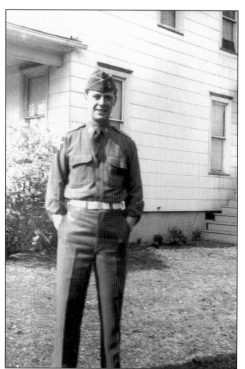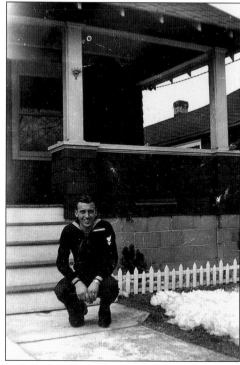

Edward Helmes (left) of East Atlantic Avenue was killed in Korea on June 1, 1952. Also in uniform, John Matousch (right), a former high school cheerleader, poses in front of his home.

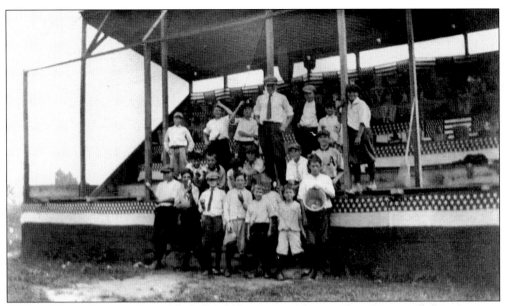

In the early 1920s, there was a baseball field by Orston Station. This photograph shows a group gathered at the grandstand on the corner of East Atlantic Avenue and Chestnut Street.

This view, looking east toward the railroad, shows Pine Street at Fourth Avenue in the 1920s.

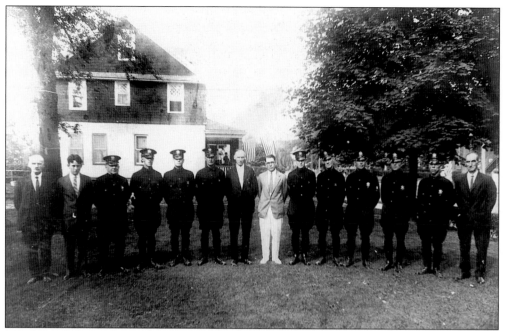

Members of the Audubon Police Department pose in 1927. The police chief at the time was John H. Bennett (in the center, wearing light clothing).

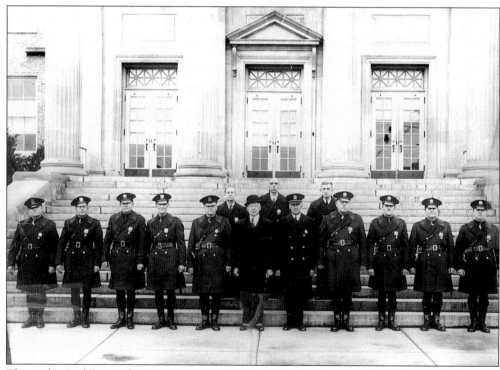

This is the Audubon Police Department in 1929. With the officers is Mayor George P. Dowling (front row, center).

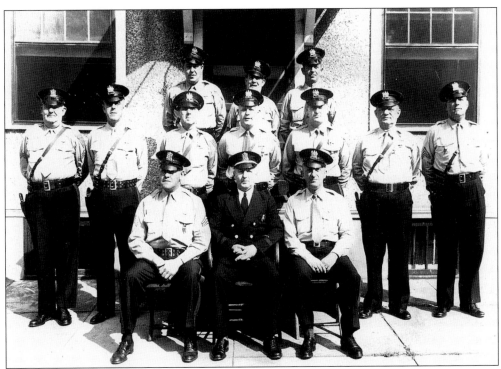

Members of the Audubon Police Department gather for a picture in the 1940s. The chief is Jack Parker (front row, center).

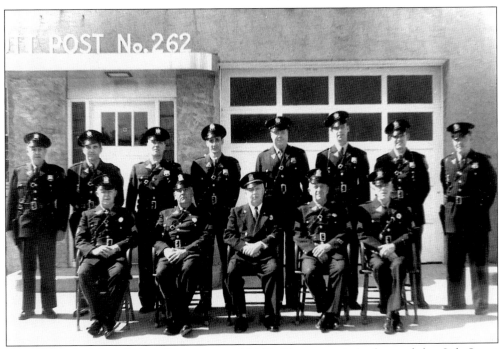

This is the Audubon Police Department of 1960. The group is in front of the Oak Street ambulance station.

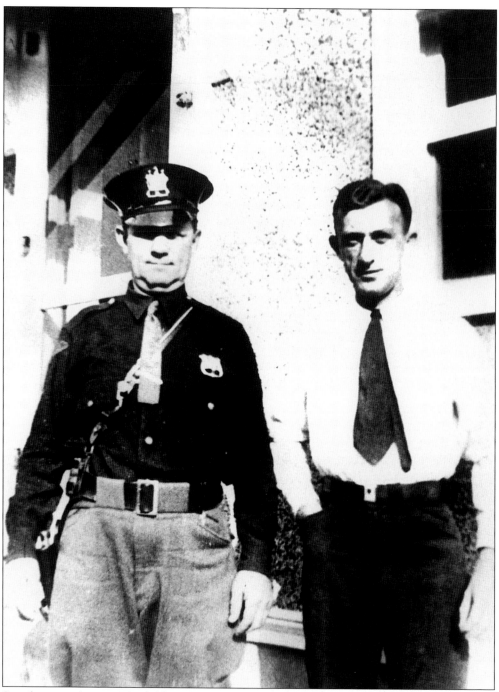

Standing together are Thorkild Andersen (left) and Vic Dorwart, patrolmen of the Audubon Police Department.

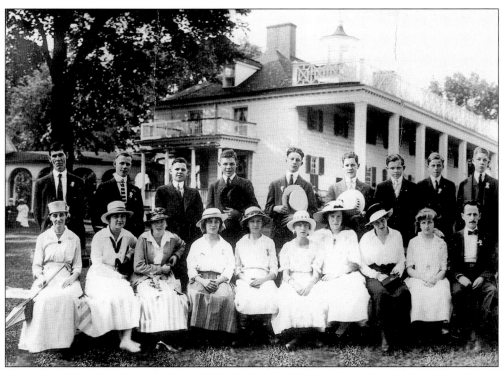

The eighth-grade class of School No. 1 takes a class trip to Mount Vernon in 1916.

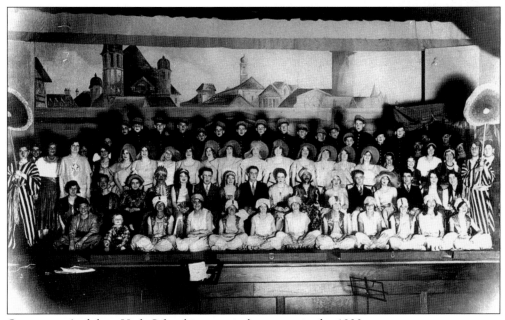

Onstage at Audubon High School is a musical operetta in the 1930s.

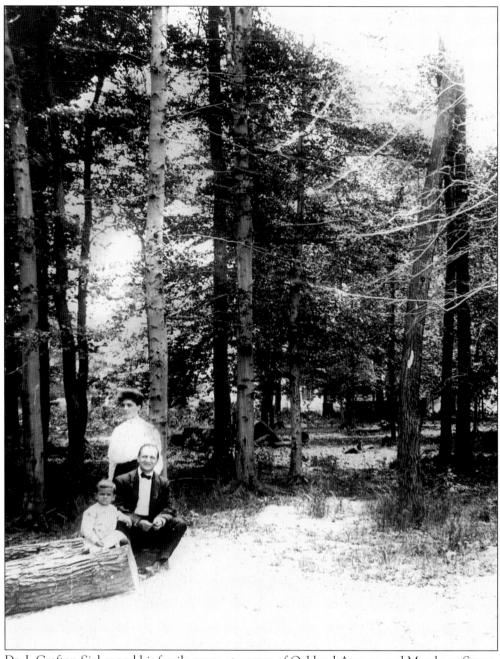

Dr. I. Grafton Sieber and his family pause at corner of Oakland Avenue and Merchant Street.

Three
SCENES OF DAILY LIFE

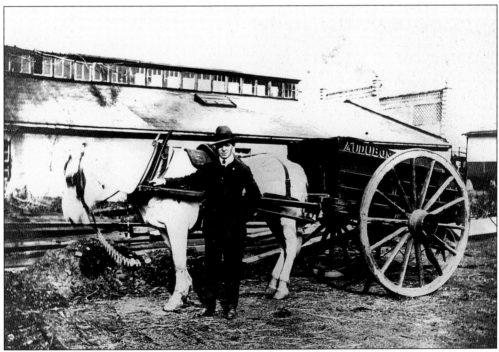

A man stands alongside the horse and coal wagon of the Audubon Ice and Coal Company
c. the early 1920s.

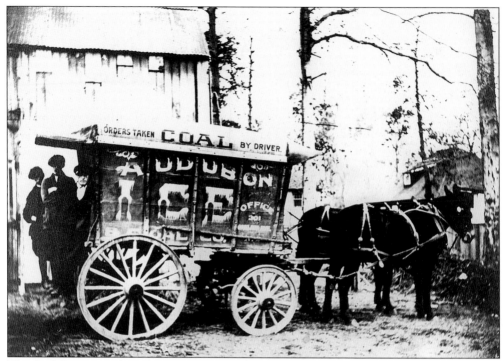

The Audubon Ice and Coal Company was owned by the Hull family. The company office was at the Hull residence, on the southwest corner of Oakland and Graisbury Avenues. The stables were on the east side of Oakland Avenue between Merchant Street and Nicholson Road.

Robert Tweed was the co-owner of the Suburban Dairies. He and William Matlack opened the dairy on Oakland Avenue in 1911. On June 11, 1924, Tweed was elected a director of the Audubon National Bank.

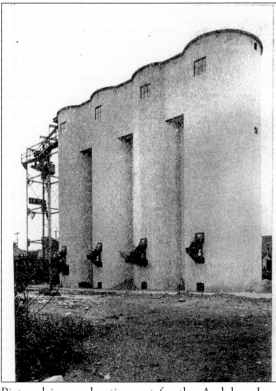

The Coal
We Deliver

will give you most value, because our modern silos insure protection against weather conditions at all times.

2240 lbs to the ton

Audubon Ice & Coal Co.
201 OAKLAND AVENUE

Bell Phone—1034 Key —74

Pictured is an advertisement for the Audubon Ice and Coal Company. The coal silos were located at West Atlantic Avenue and Nicholson Road.

Street paving is under way on Cedarcroft Avenue between Mansion and Graisbury Avenues. This picture was taken in the early 1920s.

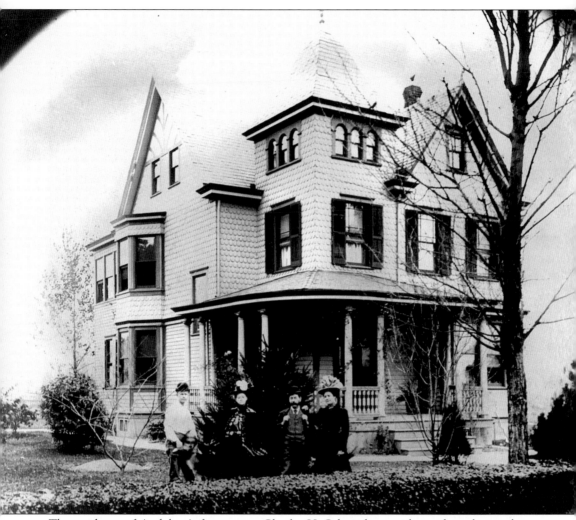

The residence of Audubon's first mayor, Charles H. Schnitzler, was located on the northwest corner of Pine Street and the White Horse Pike. Today, the site is occupied by Pine Plaza.

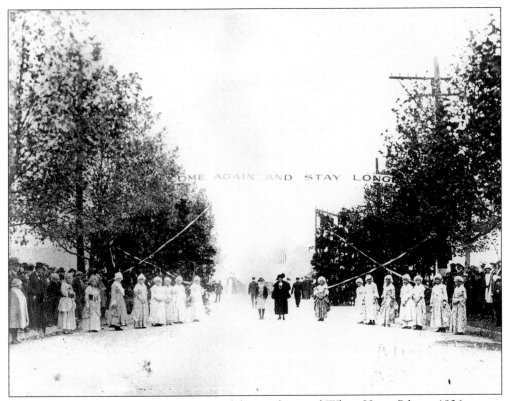

A large celebration marked the opening of the newly paved White Horse Pike in 1926.

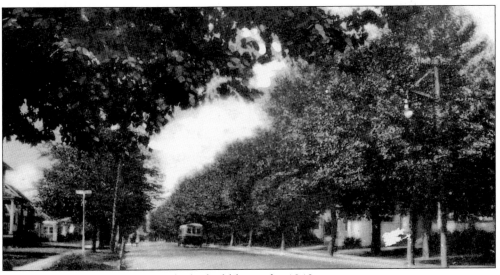

This is what the White Horse Pike looked like in the 1940s.

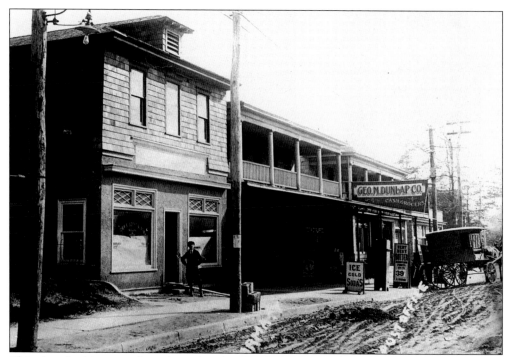

This view, looking west from the railroad in 1916, shows Merchant Street, with the Audubon National Bank (106 Merchant Street) on the first floor, the Improved Order of Redmen Tribe No. 260 on the second floor, a pharmacy, the George M. Dunlap grocery, and the post office just past the grocery.

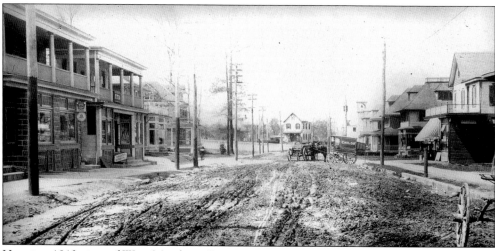

Here is a 1913 view of West Merchant Street.

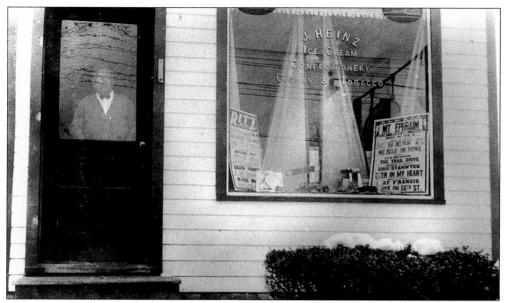

This is the front of the J. Heinz general store, on the southwest corner of Merchant Street and Wyoming Avenue.

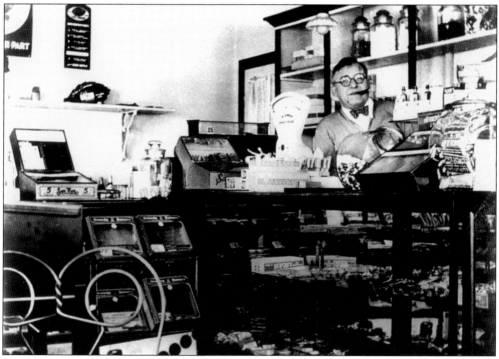

This is an interior view of the J. Heinz store. The picture was taken in the early 1940s. Note the portion of the war bonds poster (upper left).

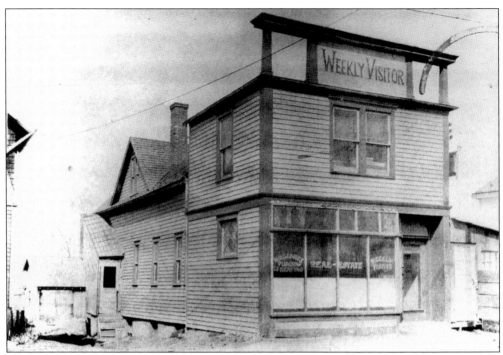

This was the home of the *Weekly Visitor* newspaper *c.* 1920. The office was located on West Merchant Street at the foot of Virginia Avenue. The building also housed a real-estate office and a plumbing and heating business.

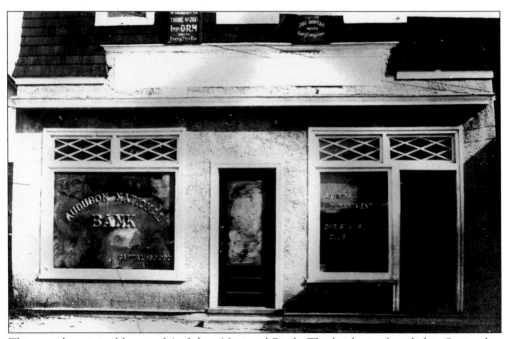

This was the original home of Audubon National Bank. The bank was founded in September 1919 with $50,000 capital. The founders were Dr. I. Grafton Sieber, Frank Morris, George Dowling, Charles Wise, and Frederick Lange.

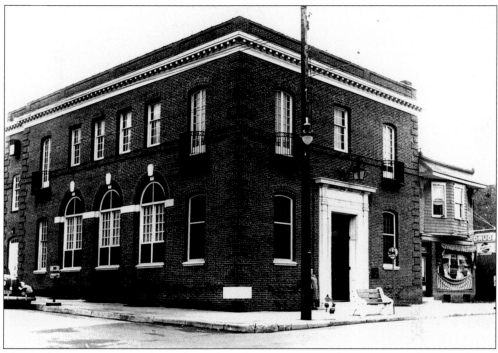

The Audubon National Bank was located on the corner of Merchant Street and West Atlantic Avenue. Note Merkles drugstore next to the bank and the public service bus stop sign in front. This photograph was taken in the early 1940s. The bank remained at this location until the mid-1990s, when it closed. It is now an auction house owned by Marty Cobb.

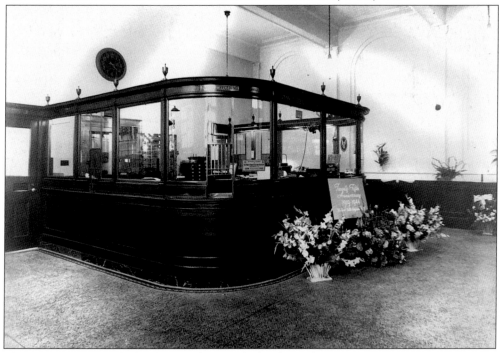

This interior view of the bank was taken on the bank's 25th anniversary, in 1944.

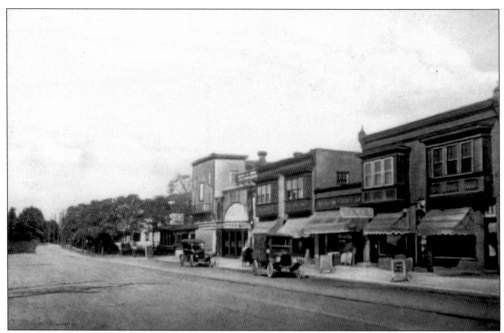

Shown is the East Atlantic Avenue business district *c.* 1925. Note the Highland Theater, the delivery truck for the Sloans and Skiles grocery store, and the trolley tracks in the foreground.

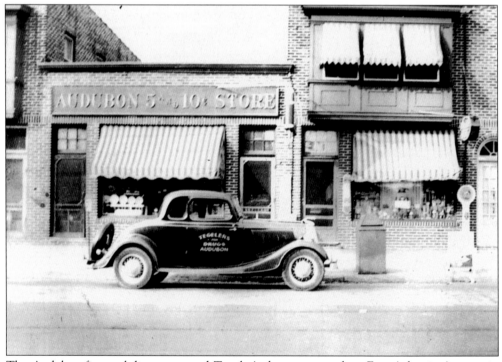

The Audubon five-and-dime store and Tegeler's drugstore stand on East Atlantic Avenue in the late 1930s.

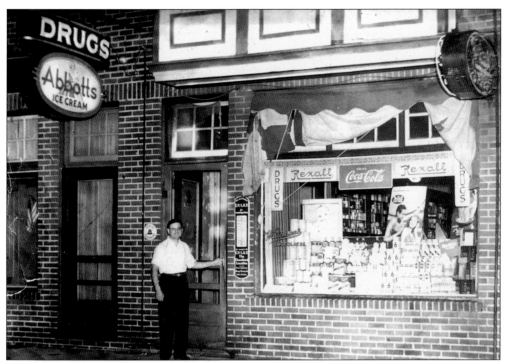

Bulk's drugstore stood on East Atlantic Avenue near Chestnut Street. These 1940 views show the exterior and interior of the drugstore.

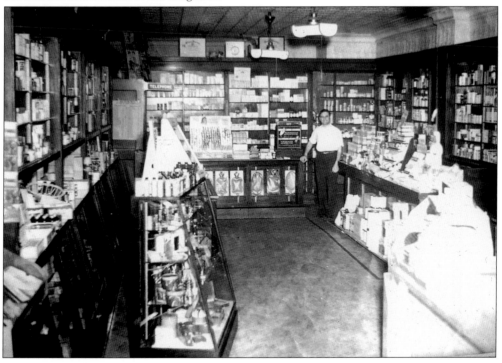

Shown is a Century Theater program cover from the early 1920s.

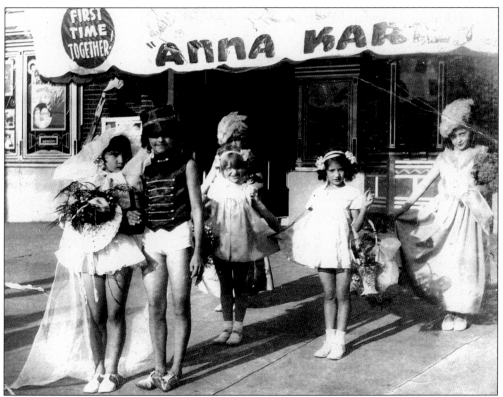

Six young performers pose in front of the Century Theater in the 1930s. The theater was located on the northeast corner of the White Horse Pike and the Kings Highway.

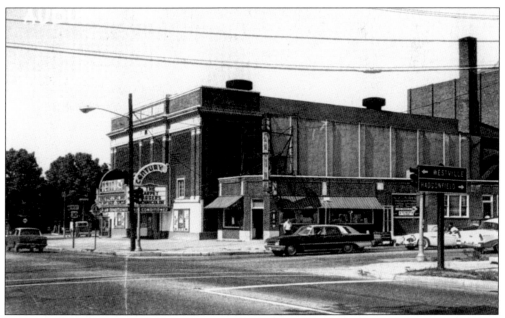

The Century Theater is shown as it appeared in the mid-1960s.

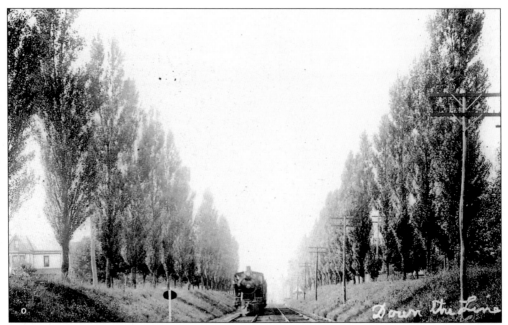

An Atlantic City–bound passenger train departs from Audubon Station *c.* 1905. The photographer is standing halfway between Merchant Street and Graisbury Avenue. (Courtesy Richard Magee.)

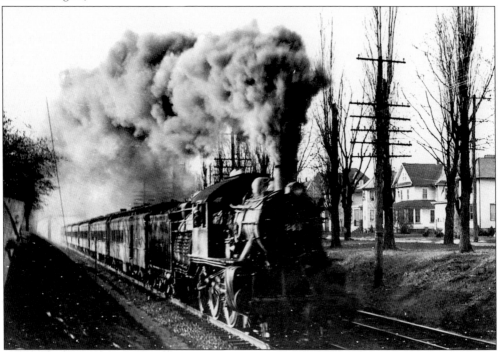

The *Sea Breeze Express* passes through Audubon just south of the Graisbury Avenue pedestrian bridge in 1935. The locomotive is a Reading Railroad camelback. When Bill Wordhoff, Audubon resident and locomotive engineer, passed through town running steam trains like the one shown, he played "Home Sweet Home" on the whistle.

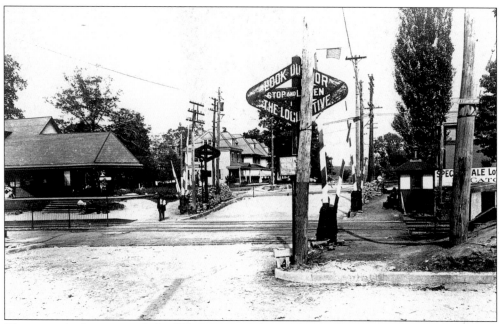

This view, looking toward the White Horse Pike on September 21, 1917, shows Audubon Station and the West Merchant Street crossing. The railroad closed the station on April 18, 1960. The building was refurbished and enlarged in the 1980s and now serves as the dental office of Dr. William Judd.

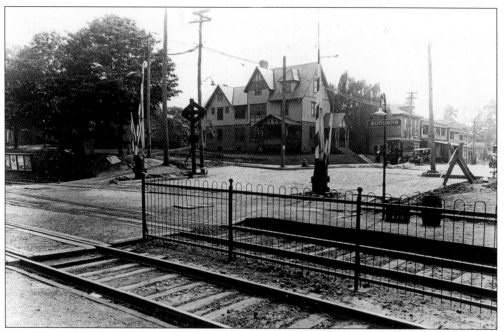

This view, taken from the Audubon Station platform looking west across Merchant Street, shows the upscale house that was demolished for the construction of the Audubon National Bank building, which still occupies the site today. Note the advertising billboards on the far left.

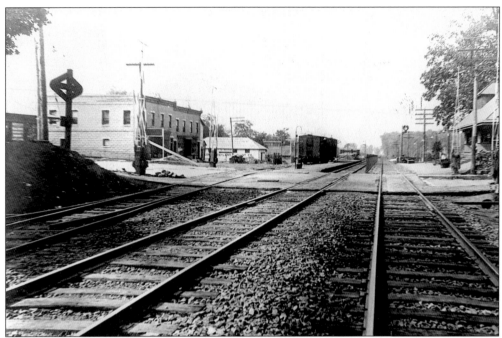

This view of the Merchant Street railroad crossing was taken from the railroad looking toward Camden on September 21, 1917. The freight cars are on the siding, which leads to the coal yard at Nicholson Road. Note the fence between the two main tracks and the Hall signal, an electric-powered automatic signal common at the time.

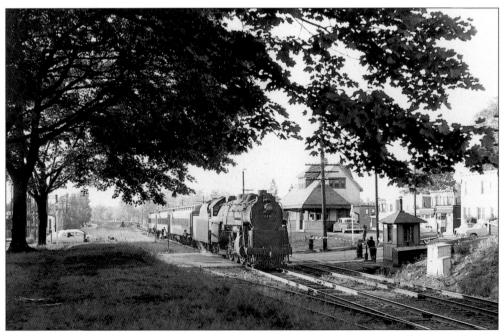

The Pennsylvania-Reading Seashore Lines train No. 609 from Camden stops at Audubon to discharge commuters on September 24, 1953. This scene was repeated night after night for decades. (Courtesy Robert L. Long.)

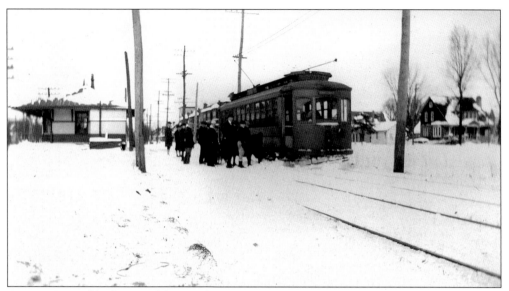

A winter snow blankets Audubon and causes a trolley derailment near Orston Station (to the left of the trolley) on January 29, 1922. After being rerailed, the Camden-bound trolley entered the tracks on East Atlantic Avenue. Note the commuters wondering how late they will arrive at work. (Courtesy Robert Stanton.)

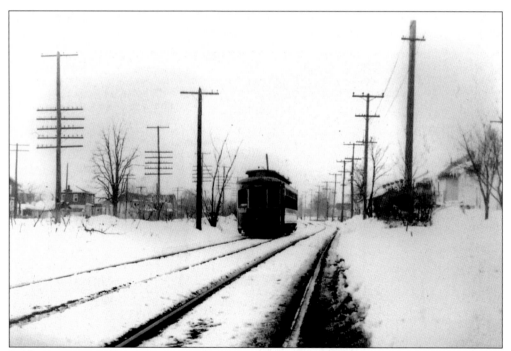

Public service trolley car No. 3162 passes through Audubon just north of the Kings Highway, headed for Haddon Heights on February 1, 1935. Regular trolley service ended on September 1, 1935. The tracks shown are on a private right-of-way, which some years after the trolleys disappeared, was paved to extend East Atlantic Avenue into Haddon Heights. (Courtesy Robert Stanton.)

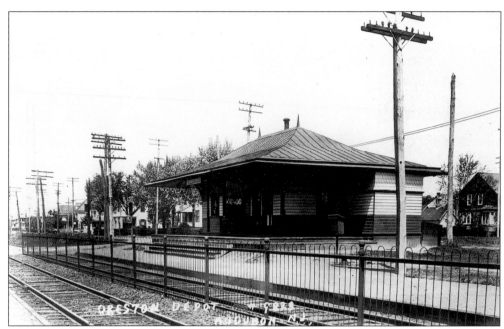

Audubon was fortunate to be served by two railroad stations: Audubon and Orston. This is a 1914 view of Orston Station, located at Chestnut Street and East Atlantic Avenue. (Courtesy Robert L. Long.)

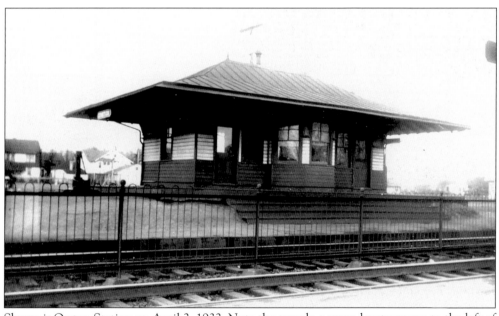

Shown is Orston Station on April 2, 1932. Note the muscle-powered water pump to the left of the structure. (Courtesy Francis B. Palmer.)

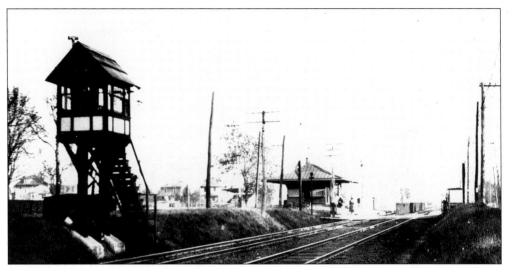

A watchman's tower stood between the railroad and East Atlantic Avenue (left). The watchman controlled the crossing gates at both the Pine and Chestnut Street crossings. Note Orston Station at the Chestnut Street crossing. The tower and the northbound main track were dismantled in December 1953. (Courtesy Robert L. Long.)

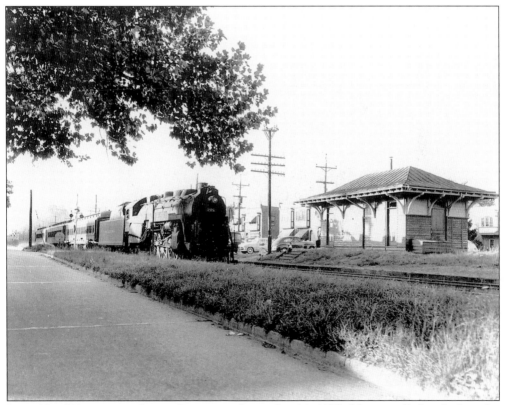

Train No. 609 arrives at Orston Station on September 24, 1953. (Courtesy Robert L. Long.)

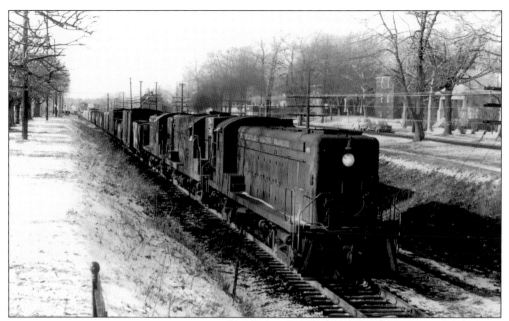

In the aftermath of a light snowfall, a Beesleys Point–bound extra passes through Audubon on a cold day in February 1966. The train is powered by three Baldwin diesel locomotives acquired by the Pennsylvania-Reading Seashore Lines in the 1950s as replacements for steam-powered engines. By this time, Audubon saw only freight trains, as the last regular passenger service was discontinued in July 1965. (Courtesy William J. Coxey.)

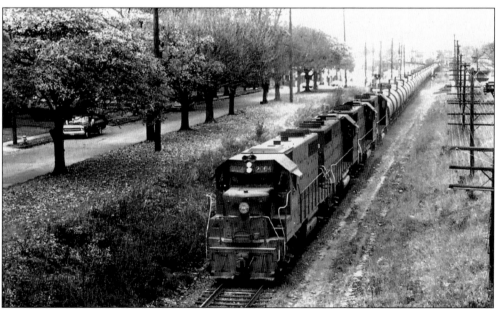

Another Beesleys Point extra passes through Audubon in November 1973. Four then-modern electromotive GP 38 locomotives acquired by the Pennsylvania-Reading Seashore Lines in 1967–1968 power the train. The tank cars are loaded with fuel for the oil-fired electric generator at Beesleys Point near Ocean City. Note that the photographer is standing on the Graisbury Avenue footbridge, which was later removed. (Courtesy William J. Coxey.)

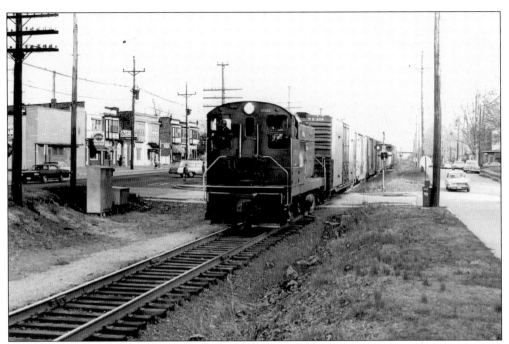

Northbound local freight CA-300 crosses Pine Street as it passes through the Orston section of town in this April 1969 scene. The train is powered by an aging Pennsylvania-Reading Seashore Lines Baldwin BS-12 diesel switcher, which is nearing the end of its service life. Note the former Highland Theater and stores in the one-block business district. (Courtesy William J. Coxey.)

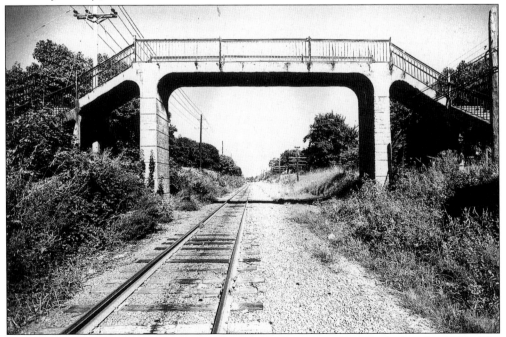

This is the Graisbury Avenue pedestrian bridge over the railroad as it looked in the 1960s. The railroad had been reduced to a single main track by this time.

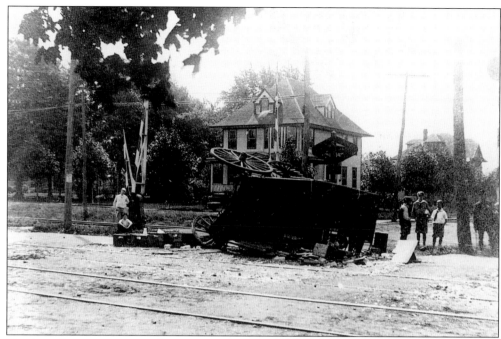

Despite safety measures, accidents sometimes occurred, as in this case in which a train struck a horse-drawn wagon at Pine Street. Note the trolley tracks in the foreground. The house in the background still stands.

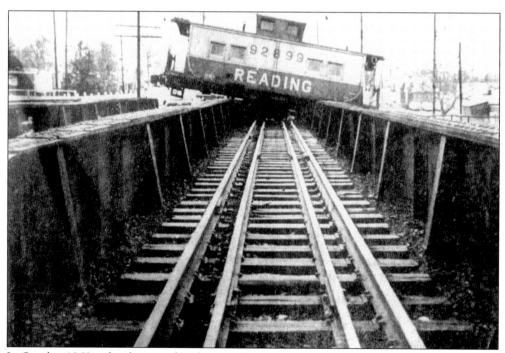

In October 1969, a freight train derailment left the train's caboose sitting the wrong way on the railroad bridge over Nicholson Road.

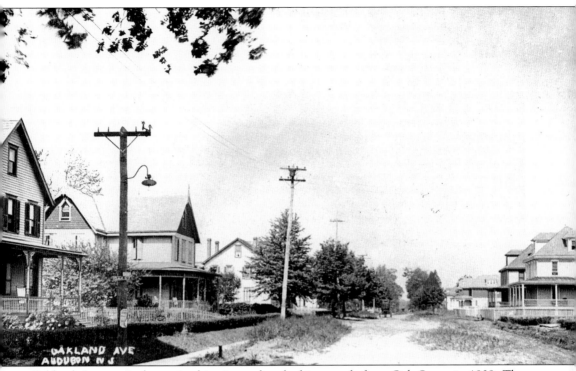

Oakland Avenue is shown in this view, taken looking north from Oak Street in 1909. The Suburban Dairies plant and stables are just beyond the left of the picture.

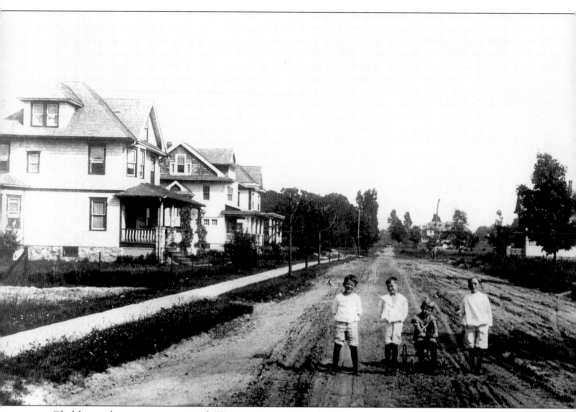

Children play on an unpaved Wyoming Avenue between Graisbury and Mansion Avenues *c.* 1921. Tom Griffith is the boy on the far right.

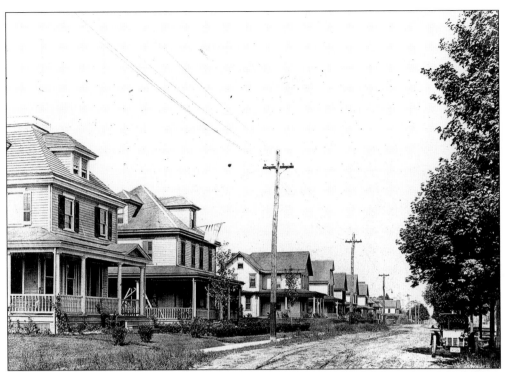

West Atlantic Avenue is pictured in this view, taken looking north from the Defender Fire Company toward Merchant Street shortly before 1920.

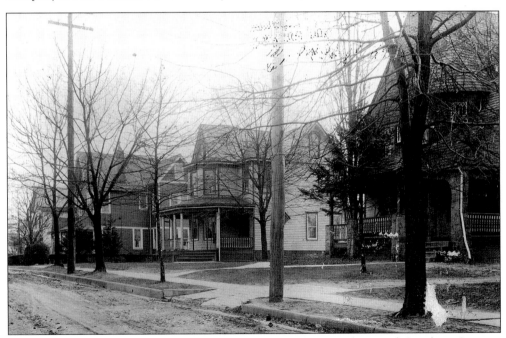

This 1921 view of West Atlantic Avenue was taken looking south toward Graisbury Avenue. These houses still stand today. Note that the sidewalks are paved and the curbs are in place, but the street is still unpaved. At one time, West Atlantic was called Edgemont Avenue.

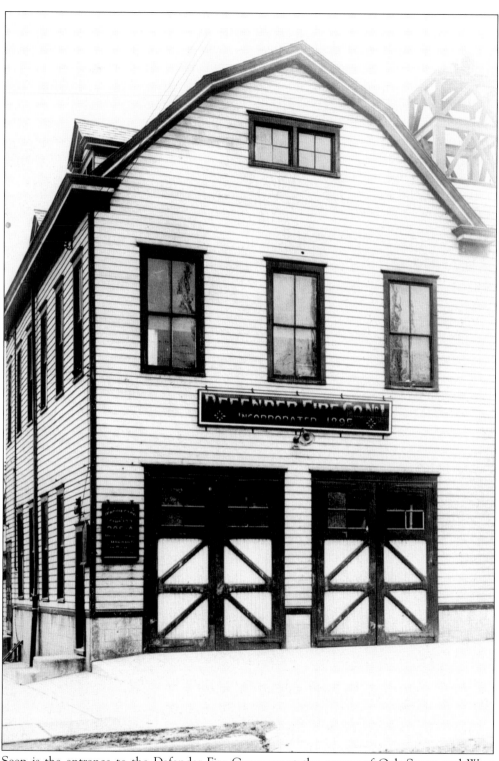

Seen is the entrance to the Defender Fire Company at the corner of Oak Street and West Atlantic Avenue. In the early 1900s, West Atlantic Avenue was known as Edgemont Avenue.

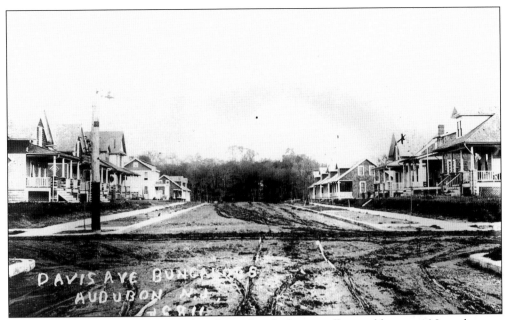

Davis Avenue is complete with sidewalks and curbs but is still a muddy street. Note the area known as the Gully in the background.

A more recent photograph of this section of Audubon shows the corner of Merchant Street and LeCato Avenue. At the end of LeCato Avenue is the Gully. (Courtesy Craig E. Burgess.)

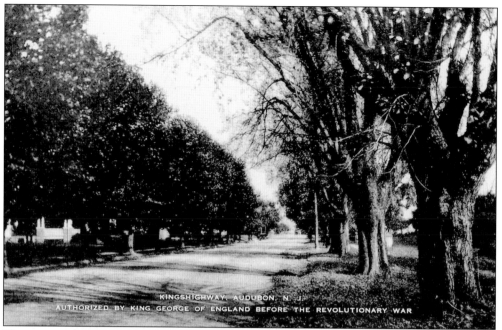

This is an early scene of the Kings Highway.

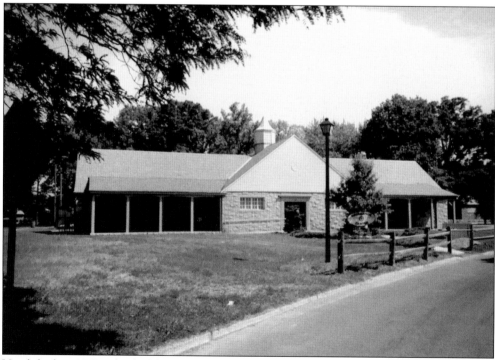

Until the late 1960s, this building housed the locker rooms for the town swimming pool. Today, it is a recreation center for the young people of Audubon.

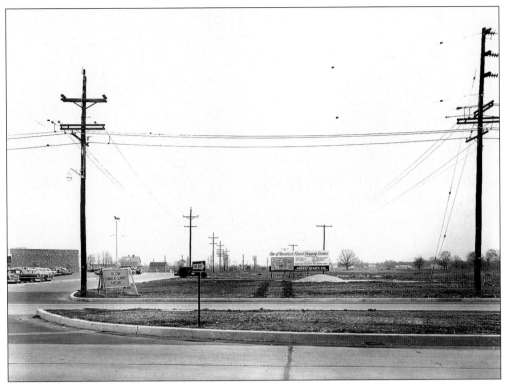

Prior to development of the Audubon Shopping Center, the area to the south of the public service right-of-way was just a field, as shown in this March 28, 1957, photograph.

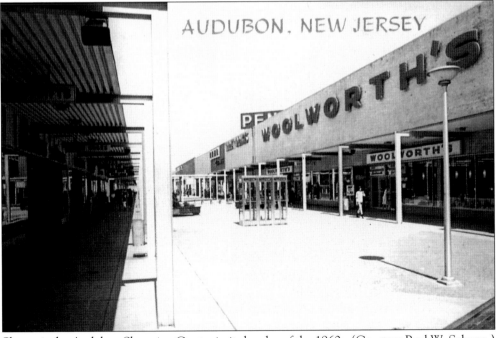

Shown is the Audubon Shopping Center in its heyday of the 1960s. (Courtesy Paul W. Schopp.)

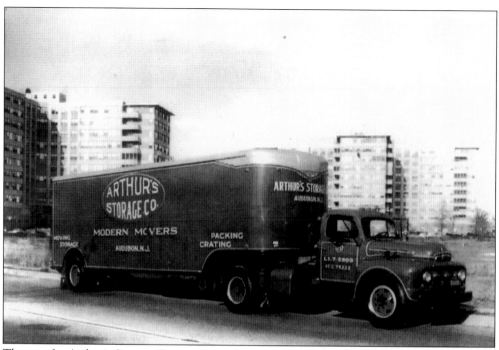

The van for Arthur's Storage Company, an Audubon-based moving and storage firm, sits near the Parkview Apartments in West Collingswood in the 1950s. (Courtesy Paul W. Schopp.)

This old steam locomotive tire was used as a fire alarm in the early days of the Defender Fire Company. It stood on West Atlantic Avenue until the 1990s.

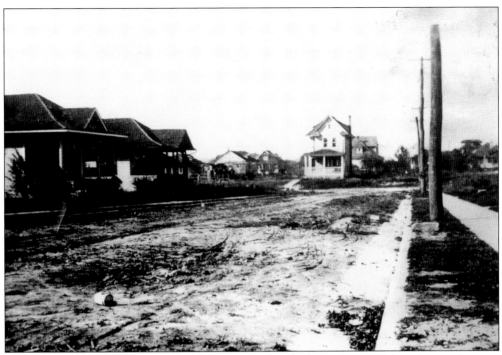

These two scenes show Elm Avenue. Both were taken looking toward Walnut Street, above in 1914 and below in 1988.

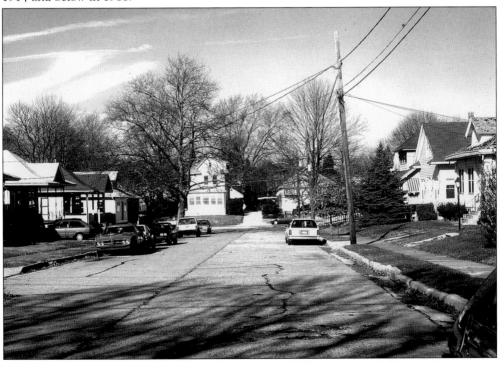

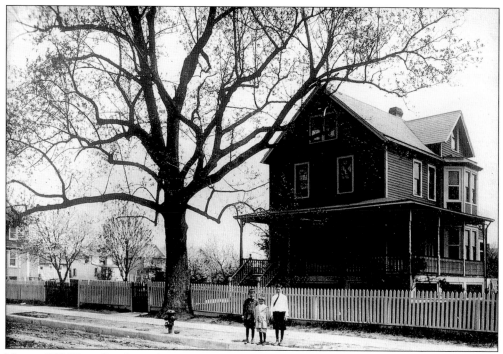

Here is 252 West Graisbury Avenue in 1905. Note the tulip poplar tree.

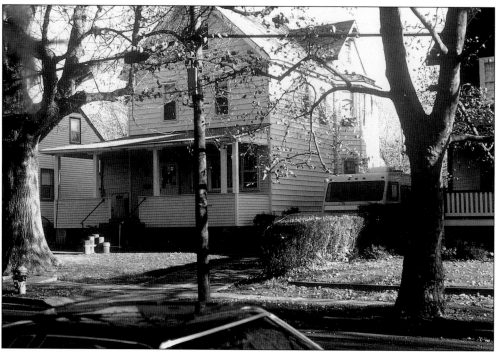

Here is 252 West Graisbury Avenue in 1985. In this scene, the tree still stands, but it was removed in 2003.

Four
PATRIOTIC HERITAGE

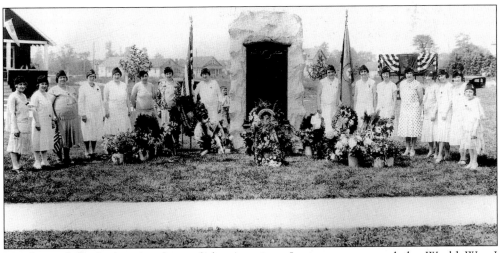

Members of the Ladies Auxiliary of the American Legion pose around the World War I memorial in front of the home of American Legion Post No. 262, at Chestnut Street and East Atlantic Avenue.

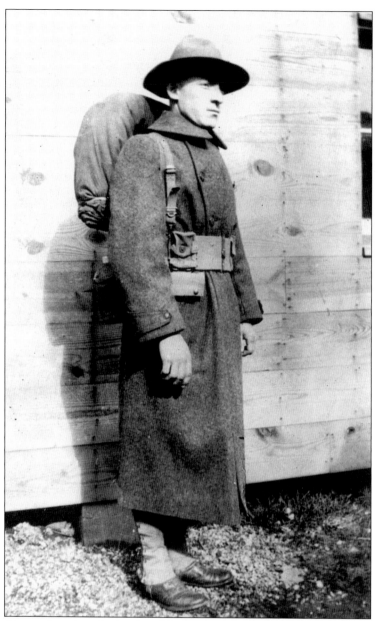

The Murray-Troutt American Legion Post No. 262 is named in memory of two Audubon heroes who fought in World War I. James L. Murray (above) enlisted in the Episcopal Hospital Unit No. 34 and sailed for Europe on December 14, 1917, arriving in England on Christmas day. After serving as ward master at the American Red Cross Military Hospital No. 3 in Paris, France, he was sent to Nantes, France. He was taken ill with pneumonia and died on October 20, 1918. In 1920, his body was sent back to this country, where it now lies in Arlington National Cemetery. William T. Troutt enlisted in February 1917 and was placed in Company D of the 3121st infantry. After arriving in Liverpool, England, in July, he was sent to France with the Lightning division, where he served at the Argonne Forest. Troutt was killed in action on October 18, 1918, and was buried on Talma farm by his comrades. In November 1920, his body was exhumed and laid to rest in Mount Moriah Cemetery in Philadelphia.

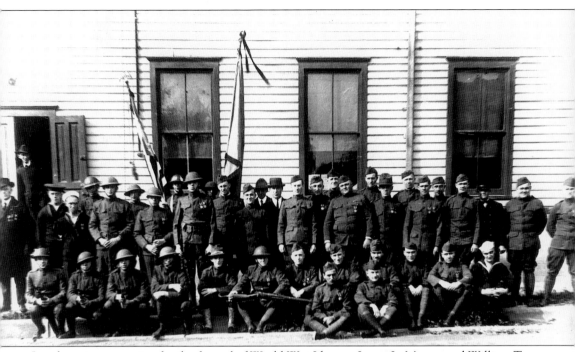

Local servicemen arrive for the funeral of World War I heroes James L. Murray and William T. Troutt and pose for a photograph on Oak Street outside the Defender Fire Company building.

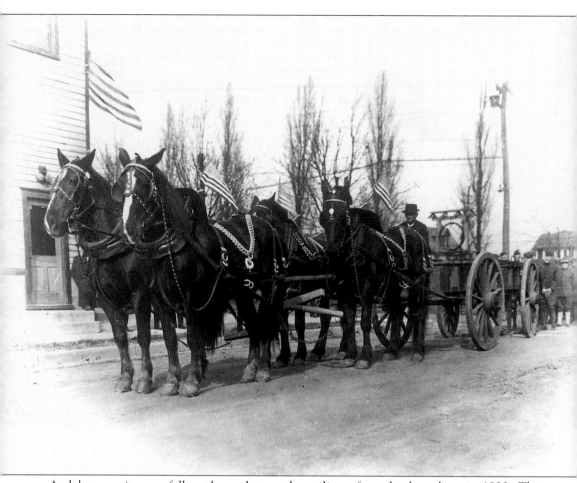

Audubon servicemen follow the casket as the military funeral takes place in 1920. This photograph was taken on Oak Street at the corner of West Atlantic Avenue. On the left is the Defender Fire Company hall.

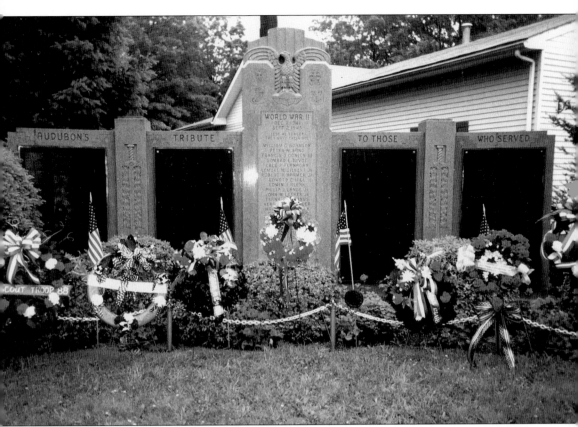

Seen is Audubon's tribute to those who served our nation in World War II. It is located on the grounds of American Legion Post No. 262 (in the background) on Chestnut Street at East Atlantic Avenue. Local organizations bring wreaths to the site each Memorial Day (known as Decoration Day until the 1950s).

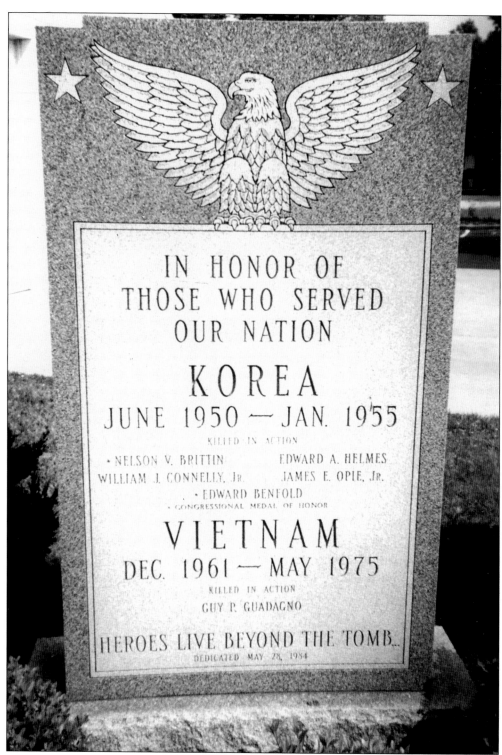

IN HONOR OF
THOSE WHO SERVED
OUR NATION

KOREA
JUNE 1950 — JAN. 1955
KILLED IN ACTION
• NELSON V. BRITTIN EDWARD A. HELMES
WILLIAM J. CONNELLY, JR. JAMES E. OPIE, JR.
• EDWARD BENFOLD
• CONGRESSIONAL MEDAL OF HONOR

VIETNAM
DEC. 1961 — MAY 1975
KILLED IN ACTION
GUY P. GUADAGNO

HEROES LIVE BEYOND THE TOMB
DEDICATED MAY 28, 1954

This memorial is to those from Audubon who served in Korea and in Vietnam. It stands in front of the Murray-Troutt American Legion Post, on Chestnut Street and East Atlantic Avenue.

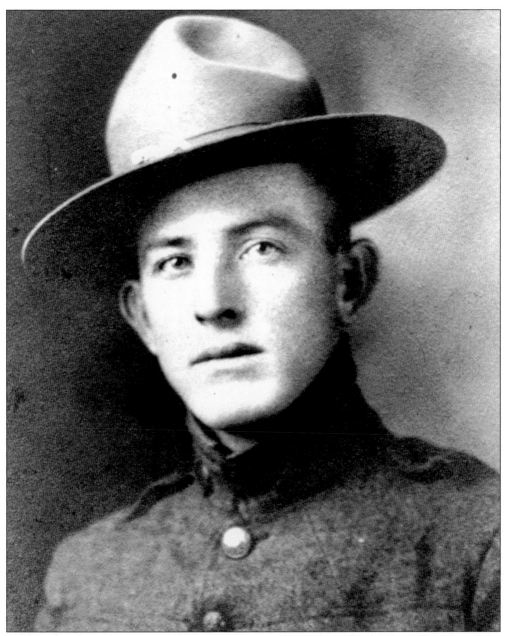

Audubon is the only town in America of its population size to have three recipients of the country's highest honor for bravery and heroism, the Medal of Honor. One of them is Cpl. Samuel M. Sampler, who served in the army during World War I. His company, having suffered severe casualties during an advance under machine-gun fire, was finally stopped. Sampler detected the position of the enemy machine guns on an elevation. Armed with German hand grenades, which he had picked up, he left the line and rushed forward in the face of heavy fire until he was near the hostile nest. There, he grenaded the position. His third grenade landed among the enemy, killing two, silencing the machine guns, and causing the surrender of 28 Germans, whom he sent to the rear as prisoners. As a result of his act, the company was immediately enabled to resume the advance.

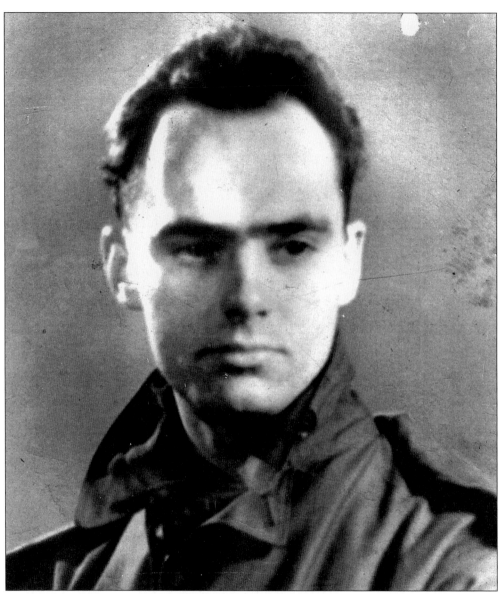

Army veteran Nelson V. Brittin graduated from Audubon High School in 1939. He served for four years during World War II and then reenlisted in the army in 1948. Serving as sergeant first class in Company I, 19th Infantry Regiment, he volunteered to lead his squad up a hill at Yong-Ni, Korea, on March 7, 1951. With meager cover against murderous fire from the enemy, he tossed a grenade at the nearest enemy position. On returning to his squad, he was knocked down and wounded by an enemy grenade. Refusing medical attention, he replenished his supply of grenades and returned, hurling grenades into hostile positions and shooting the enemy as they fled. When his weapon jammed, he leaped into foxholes and killed the occupants with his bayonet and the butt of his rifle. In his sustained and driving action, he killed 20 enemy soldiers and destroyed 4 automatic weapons, enabling his company to attain its objective. Less than 100 yards up the hill, when his squad came under machine-gun fire, he charged again and ran directly into a burst of automatic fire that killed him instantly. He was awarded the Medal of Honor for extreme bravery.

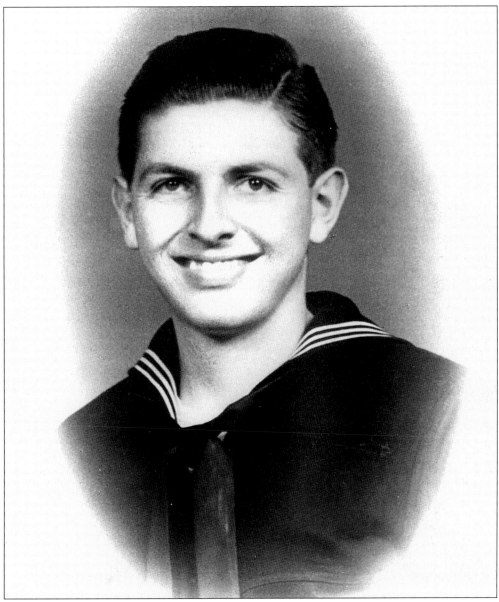

Navy corpsman Edward C. Benfold graduated from Audubon High School in 1949. He was assigned to Korea and worked as a hospital corpsman, attached to a company in the 1st Marine Division. On September 5, 1952, when his company was subjected to heavy artillery and mortar barrages, he resolutely moved from position to position in the face of intense hostile fire, treating the wounded. When the platoon area in which he was working was attacked from both the front and the rear, he moved forward to an exposed ridge line where he observed two marines in a large crater. As he approached the two men to determine their condition, an enemy soldier threw two grenades into the crater while two other enemy soldiers charged the position. Picking up a grenade in each hand, Benfold leaped out of the crater and hurled himself against the onrushing hostile soldiers, pushing the grenades against their chests, killing both the attackers and mortally wounding himself, but saving the lives of his two comrades. For his exceptional courage, he was awarded the Medal of Honor posthumously.

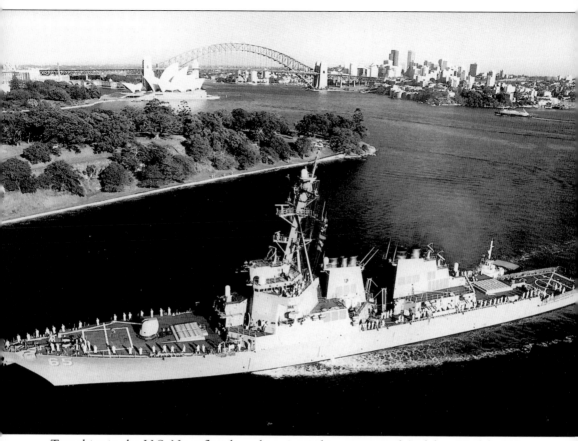

Two ships in the U.S. Navy fleet have been named in memory of Audubon Medal of Honor recipients. Shown is one of them, the USS *Benfold* (DDG-65), named in honor of Korean War hero Edward C. Benfold. This destroyer was commissioned on March 30, 1996, in San Diego, California. It serves in the Pacific Fleet.

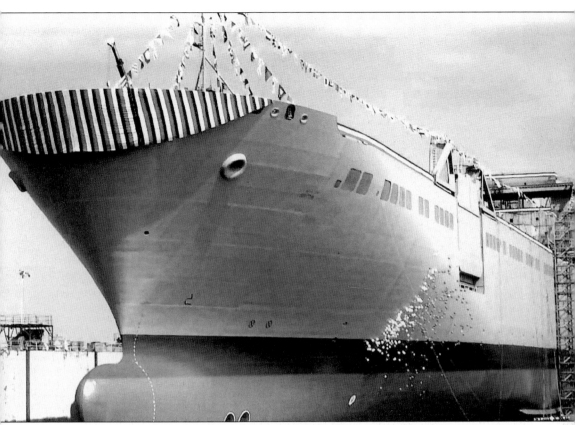

The other ship named in memory of an Audubon Medal of Honor recipient is the USNS *Brittin* (T-AKR 305), named in honor of Korean War hero Nelson V. Brittin. A supply ship, it was christened on October 20, 2000, in New Orleans, Louisiana, and is one of seven ships in the Bob Hope class. (Three of the four student designers of the Medal of Honor memorial in Audubon were in attendance at the ceremony.)

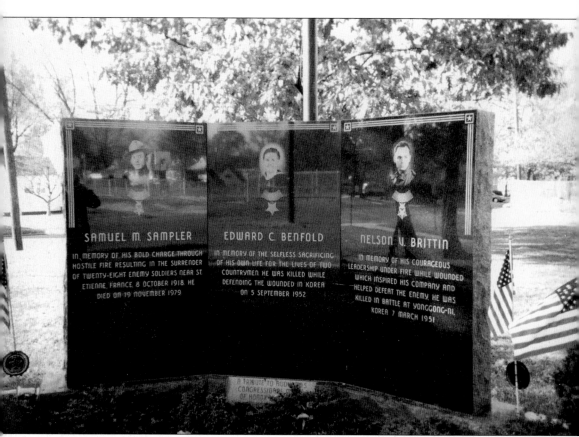

On July 4, 1994, the Medal of Honor memorial on the campus of Audubon High School was dedicated. Among the guests at the dedication ceremony were members of the families of Samuel M. Sampler, Nelson V. Brittin, and Edward C. Benfold; one of the two marines whose lives were saved by the heroic act of Benfold on September 5, 1952; and the first captain of the USS *Benfold,* Cmdr. Mark E. Ferguson III. The memorial was designed by four students in the Audubon High School class of 1994—Scott Johnson, Melanie Aubrey, Anthony Simeone, and Derek Everman.

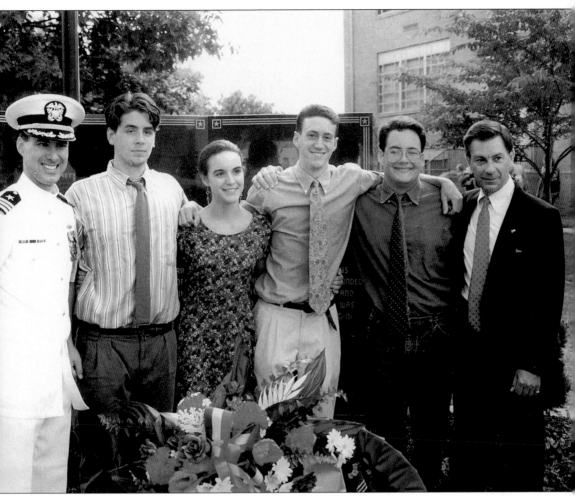

Taking part in the July 4, 1994, dedication of the Medal of Honor memorial on the campus of Audubon High School are, from left to right, Cmdr. Mark E. Ferguson III; Audubon High students Derek Everman, Melanie Aubrey, Scott Johnson, and Anthony Simeone; and school principal William Westphal.

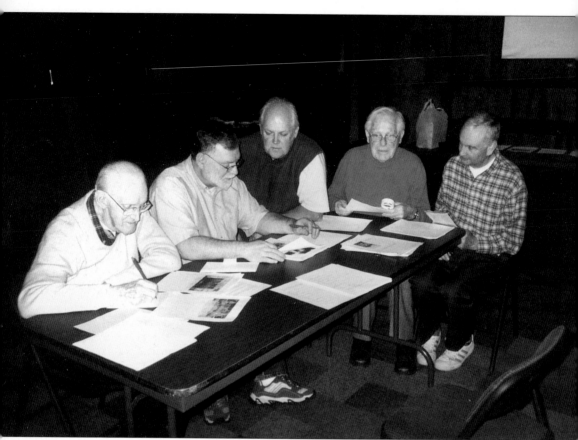

Thanks are extended to the dedicated individuals who made this pictorial history a reality for Audubon's 100th anniversary. Seen working on the project are, from left to right, Jack Taylor, Ed Helmes, Paul Helmes, Walter Casebeer, and Richard Magee. (Courtesy Craig E. Burgess, president, Audubon Historical Society.)